EAST ANGLIAN ARCHAEOLOGY

Frontispiece:
a) a selection of medieval armorial horse furniture held in Norwich Castle Museum; b) an engrailed octagonal pendant displaying the arms of Morley, of Norfolk
Photos: D. Wicks

Medieval Armorial Horse Furniture in Norfolk

by Steven Ashley

illustrations by
Steven Ashley

East Anglian Archaeology
Report No. 101, 2002

Archaeology and Environment
Norfolk Museums and Archaeology Service

EAST ANGLIAN ARCHAEOLOGY
REPORT NO.101

Published by
Archaeology and Environment Division
Norfolk Museums and Archaeology Service
Union House
Gressenhall
Dereham
Norfolk NR20 4DR

in conjunction with
The Scole Archaeological Committee

Editor: Stanley West
Managing Editor: Jenny Glazebrook

Scole Editorial Sub-committee:
Brian Ayers, Archaeology and Environment Officer, Norfolk Museums and Archaeology Service
David Buckley, County Archaeologist, Essex Planning Department
Keith Wade, Archaeological Service Manager, Suffolk County Council
Peter Wade-Martins
Stanley West

Set in Times Roman by Jenny Glazebrook using Corel Ventura™
Printed by Witley Press Ltd., Hunstanton, Norfolk

© STEVEN ASHLEY, AND ARCHAEOLOGY AND ENVIRONMENT DIVISION,
NORFOLK MUSEUMS AND ARCHAEOLOGY SERVICE

ISBN 0 905594 34 7

For details of *East Anglian Archaeology*, see last page

Cover photograph:
Detail from a thirteenth-century aquamanile (see Pl. V)
(*Soprintendenza per i Beni Artistici e Storici per le Provincie di Firenze-Pistoia-Prato*)

Contents

List of Contents	v
List of Plates	vi
List of Figures	vi
Abbreviations	vi
Acknowledgements	vii
Summary	vii

Introduction	1
The Ordinary	1
The Armory	2
List of Illustrated Finds with their Blazons	2
Glossary	2
Conventions	2

The Finds	4
Use	4
Manufacture	4
Non-armorial Horse Furniture	4
Early Examples of Armorial Horse Furniture	5
Shield-shaped Pendants, Studs and Mounts	8
Lozengiform Pendants, Studs and Mounts	16
Square and Rectangular Pendants, Mounts, Suspension-mounts and Studs	18
Circular Pendants, Studs and Mounts	18
Trefoil, Quatrefoil and Elaborate Quatrefoil Pendants, Stud and Mount	23
Octagonal and Elaborate Pendants	23
Elaborate Sets	23
Armorial Badges	23

Discussion	27
Origins and Development	27
Distribution	30
Ownership	30
Decline	31
Further Work	32
Endnotes	32

Appendix 1: Ordinary	34
Bars	34
Barry	34
?Barry/Paly	34
Beast	34
Bend	39
Bends	40
?Bendy	40
?Bezanty/Platty	40
Bird	40
Birds	41
Castle	41
Checky	41
Chevron	42
Chevrons	42
Chief	42
?Combs	43
Cross	43
Crown	45
Crowns	45
Escarbuncle	45
Escutcheon	45
Estoile	45
Fermaux	45
Fess	45
Fish	46
Fleur-de-lis	46
Flower	47
Foil	47
Fret	47
Fretty	48
Fusils	48
Gyronny	48
Head	48
Human	48
?Knot	48
Label	49
Leaf	49
Leaves	49
Letter	49
?Lozenges	49
Lozengy	49
Mascules	49
Mitres	49
Monster	49
Mount	50
Mullet	50
Pall	50
Paly	50
Quarterly	50
Saltire	51
Star	51
Tree	51
Trumpets	52
Vair	52
Wheel	52
Wings	52

Appendix 2: Armory	53
Appendix 3: List of Illustrated Finds with their Blazons	55
Appendix 4: Glossary	59
Bibliography	63
Index, by Sue Vaughan	67

List of Plates

Frontispiece	a) a selection of medieval armorial horse furniture held in Norwich Castle Museum, b) an engrailed octagonal pendant displaying the arms of Morley, of Norfolk		Pl. III	*Two cranes confronted* on a shield supported by a Romanesque lion, at the castle of Roger I, Adrano, Sicily	29
Pl. I	Detail from a late eleventh/early twelfth-century tympanum showing St George mounted on a horse displaying harness pendants, church of St George, Fordington, Dorset	27	Pl. IV	*Two birds addorsed regardant* within running vine decoration, in the cloisters of Monreale cathedral, Sicily	29
Pl. II	Romanesque carving of a mounted Norman knight, church of St Margaret, Swannington, Norfolk	28	Pl. V	A thirteenth-century aquamanile in the form of an equestrian English prince	31
			Pl. VI	Detail from an early thirteenth-century English Apocalypse	33

List of Figures

Fig.1	Map of Norfolk showing distribution of finds listed in the Ordinary	2	Fig.15	Shield-shaped studs, scale 1:1	15
Fig.2	Conventions for tinctures	3	Fig.16	Shield-shaped mounts, scale 1:1	16
Fig.3	Lead trial-piece or *patron* for a shield-shaped pendant, scale 1:1	4	Fig.17	Lozengiform pendants, scale 1:1	17
Fig.4	Iron shield-shaped pendant, scale 1:1	4	Fig.18	Lozengiform studs and mounts, scale 1:1	18
Fig.5	Twelfth/thirteenth-century non-armorial horse furniture, scale 1:1	5	Fig.19	Square and rectangular pendants, mounts, suspension-mounts and studs, scale 1:1	19
Fig.6	Twelfth/early thirteenth-century pendants, mount and suspension-mounts, scale 1:1	6	Fig.20	Circular pendants, studs and mounts, scale 1:1	20
Fig.7	Twelfth/early thirteenth-century pendants, mount and suspension-mount, scale 1:1	7	Fig.21	Trefoil, quatrefoil and elaborate quatrefoil pendants, scale 1:1	21
Fig.8	Late twelfth/thirteenth-century elaborate set, scale 1:1	8	Fig.22	Elaborate quatrefoil pendants, stud and mount, scale 1:1	22
Fig.9	Late twelfth/thirteenth-century pendants and mount, scale 1:1	9	Fig.23	Octagonal and elaborate pendants, scale 1:1	24
Fig.10	Shield-shaped pendants, scale 1:1	10	Fig.24	Banners, rotating shields and lozenge, straphooks and pendant from elaborate set, scale 1:1	25
Fig.11	Shield-shaped pendants, scale 1:1	11	Fig.25	Armorial badges on pendants, mounts and a stud, scale 1:1	26
Fig.12	Shield-shaped pendants, scale 1:1	12	Fig.26	Types of cross represented in the Ordinary	61
Fig.13	Shield-shaped pendants, scale 1:1	13			
Fig.14	Shield-shaped pendants, suspension-mount, lobed rectangular pendant and rectangular strap-ends, scale 1:1	14			

Abbreviations

Archaeol. J	*Archaeological Journal*	*LMMC*	*London Museum Medieval Catalogue* (Ward-Perkins 1940, reprinted 1954, 1967)
b.	born		
BFAC	Burlington Fine Arts Club 1916, exhibition catalogue	m.	married
		NCM	Norwich Castle Museum
Cambs.	Cambridgeshire	NG	Nick Griffiths
CMAG	City Museum and Art Gallery, Birmingham 1936, exhibition catalogue	Norf.	Norfolk
		Norfolk Archaeol.	*Norfolk Archaeology*
Cumb.	Cumberland	Northumb.	Northumberland
d.	died	Notts.	Nottinghamshire
Dors.	Dorset	Rut.	Rutland
FAD	Field Archaeology Division, Norfolk	SJA	Author
Glou.	Gloucestershire	SMR	Sites and Monuments Record, Norfolk
Hants.	Hampshire	Som.	Somerset
Here.	Herefordshire	s. and h.	son and heir
Hunts.	Huntingdonshire	Suff.	Suffolk
KLM	Kings Lynn Museum	Surr.	Surrey
Leic.	Leicestershire	Suss.	Sussex
Lincs.	Linconshire	wid.	widow
		Yorks.	Yorkshire

Acknowledgements

I am very grateful to the following: all of the many metal detectorists and metal detecting clubs in the county who brought in objects for identification and recording, without whose co-operation this work would not have been possible; the staff of the Department of Archaeology in Norwich Castle Museum, especially the late Sue Margeson, John Davies, Helen Geake, Bill Milligan and Kate Sussams; my colleagues in both arms of the Field Archaeology Division of the Norfolk Museums Service, in particular Andrew Rogerson, David Gurney, Edwin Rose and Peter Wade-Martins of Norfolk Landscape Archaeology, Myk Flitcroft for his help in setting up a database for the Ordinary, Andy Crowson, Niall Donald and Mark Hoyle, all of the Norfolk Archaeological Unit, for subsequent assistance with computing queries; the Norfolk Archaeological Unit for grants of paid time in which to take the preliminary examinations of the Heraldry Society and draw a number of finds held by Norwich Castle Museum; Oliver Bone of Thetford Museum; King's Lynn Museum; David Wicks for general help with photography, and for the frontispiece photographs; Nick Griffiths for much help and encouragement; Sandy Heslop for agreeing to supervise me during the writing of the dissertation, and for many helpful comments; Melanie Rolfe, Martin Biddle, John Dent and Tony Sims for reading a copy of the original text; N. Meeks of the British Museum for information on copper-oxide deposits; Christopher Gravett of the Royal Armouries for discussing with me the dating of 'kite-shaped' shields; Stephen Heywood for commenting on the dating of Romanesque decorative motifs in architecture; Dr M. Siddons, Wales Herald Extraordinary for advice on armorial badges; Stefania Bavastro for her kind help in Italy with obtaining Plate V and the cover photograph, and the master and fellows of Trinity College, Cambridge for permission to reproduce Plate VI. I am also extremely grateful to both the outside reader, John Cherry, and to the editor, Stanley West, for their constructive comments on this volume.

Above all, I am indebted to Andrew Rogerson, not only for all of his help, advice and enthusiasm during the writing of my dissertation, and subsequently, this monograph, but also for his, and his family's, kindness, hospitality and, most importantly, friendship, over the past twenty two years.

Summary

All known examples of armorial horse furniture held on the Norfolk Sites and Monuments Record, with the provenance of the vast majority accurately recorded, have been brought together in this book and 246 examples are illustrated. Arms are attributed with local, national and European connections, and changes in form and decoration are analysed, resulting in a revision of some conventional dating.

One of the most interesting outcomes of the study is the indication that the heraldic decoration of horse furniture got underway during the second and third quarters of the twelfth century, somewhat earlier than has previously been generally accepted. The late thirteenth and early fourteenth centuries saw the maximum popularity of enamelled pieces and thereafter a slow decline set in.

Résumé

Tous les exemples connus de harnais avec armoiries conservés aux Archives des monuments et sites du Norfolk ont été réunis dans ce livre. La plupart de ces pièces ont une origine précise et 246 d'entre elles sont présentés dans le livre avec des illustrations. Les armoiries sont attribuées en précisant leurs relations sur le plan local, national et européen, et les variations de forme et de décoration sont analysées, ce qui entraîne dans certains cas la révision des datations généralement admises.

L'une des conclusions les plus intéressantes de cette étude porte sur le fait que la décoration héraldique des harnais débuta pendant la période comprise entre les années 1125 et 1175, alors que l'on pensait généralement que ce type de décoration était plus tardif. C'est à la fin du treizième et au début du quatorzième siècle que les pièces en émaux furent les plus répandues, avant que ne s'amorce un lent déclin.

(Traduction: Didier Don)

Zusammenfassung

In diesem Buch mit 246 Illustrationen sind alle bekannten, im *Norfolk Sites and Monuments Record* festgehaltenen Beispiele heraldischen Pferdeschmucks zusammengestellt, dessen Ursprünge zum überwiegenden Teil genau dokumentiert sind. Die Wappen sind mit ihren lokalen, nationalen und europäischen Verbindungen dargestellt. Dazu werden Veränderungen bei Form und Schmuckelementen analysiert, was in einigen Fällen zu einer Revision der bisher angenommenen Datierung führte.

Zu den interessantesten Ergebnissen der Untersuchung zählt, dass die heraldische Dekoration von Pferdegeschirr bereits im 2. und 3. Quartal des 12. Jahrhunderts und damit etwas früher als bisher allgemein angenommen begann. Die Beliebtheit emaillierter Objekte erreichte im späten 13. und frühen 14. Jahrhundert ihren Höhepunkt und ebbte danach allmählich wieder ab.

(Übersetzung: Gerlinde Krug)

for Mimi and Antonia

'This worthy churchman rode upon a
well-fed, ambling mule, whose furniture
was highly decorated...'

Sir Walter Scott, *Ivanhoe*

'People took to wearing little golden bells
on their belts and collars and the very
horses wore hundreds of medals, engraved
or enamelled with images and emblems,
every one of which is now a museum piece'

E. Panofsky, *Early Netherlandish Painting*

'Heraldry, it is to be observed, serves its
purpose even to-day, when the face of the
owner is obscured, not by the visor of the
helmet, but by the dust of centuries, and
gives, I think, to these little shields a
personal and living touch'

W. de C. Prideaux, *Notes on Medieval
Enamelled Armorial Horse Trappings with
especial Reference to a Weymouth Find*

Introduction

Decorative horse furniture has long been known through its depiction in contemporary manuscript illustrations such as the *Mappa Mundi* of *c.*1300 (Griffiths 1995, 62, fig.46) and the English Apocalypse, Plate VI, this volume. It also appears in paintings and tapestries, and is represented both on seals and on aquamaniles (*cf.* Digby and Hefford 1971, plate 9; Wagner 1978, 12–13, no. 11; Nelson 1916, plates 2a and 2b; and Plate V and Cover photo, this volume).

Antiquarian interest in finds of armorial horse furniture appears to have been first expressed in a note in the *Archaeological Journal* for 1846 recording some recent discoveries. Subsequently, Charles Roach-Smith published a series of these artefacts from the Faussett Collection (1868), and numerous short notes appeared in a variety of archaeological journals, usually on individual pieces or on small groups of finds (*e.g.* Clinch 1910, Hemp 1936 and Shortt 1951). These objects also appear in catalogues produced either for museum collections (British Museum 1907, and Rye 1909), or specifically for exhibitions on heraldry and medieval applied arts (*e.g.* Burlington Fine Arts Club 1916, City Museum and Art Gallery, Birmingham 1936, and Alexander and Binski 1987). Their particular interest to the 'heraldic student' was signalled by T.B.Jenkins in *The Coat of Arms* (1958–9).

A classification of 'Heraldic pendants and Badges' was first attempted by Ward-Perkins in the *London Museum Medieval Catalogue* of 1940. He followed this in 1949 with a discussion in the *Antiquaries Journal* on 'elaborate sets', prompted by the discovery of a particularly fine Italian example which had been re-used as a reliquary. A note on a small selection of Norfolk pendants was published by Margeson in *Norfolk Archaeology* in 1979. More recently, papers by Griffiths (1986, 1989 and 1995), Cherry (1991), and Goodall and Woodcock (1991) have added greatly to the published corpus of material. A glance through the pages of either of the two popular national metal-detecting magazines, *The Searcher* or *Treasure Hunting*, will demonstrate the regularity with which items of medieval horse furniture continue to be discovered. A national survey of this material, both armorial and non-armorial, by Nick Griffiths, has been underway for some years now.

In May 1995 the author began to draw and blazon examples of medieval armorial pendants, mounts and related objects (derived in the main from horse-harness), which were being brought into the various offices of the Norfolk Museums Service by their finders for identification. The intention was to prepare a catalogue of these artefacts, an ordinary of the arms displayed thereon, and a discussion concerning their dating and significance, for submission as a dissertation towards the Diploma of the Heraldry Society (Ashley 1999a). In an attempt to provide a record as comprehensive as possible the author examined all previous entries (250+) in the County Sites and Monuments Record for Norfolk relating to these various classes of object, and where possible, incorporated this information into the Ordinary. As the vast majority of finds were made by metal-detectorists, most of whom belong to detecting clubs across the county, it was possible to contact many of the owners, and then to draw and blazon many examples which remain in private possession. All relevant objects in the county museum collections were also drawn and described. In the case of objects not examined 'in hand specimen' any photographs or drawings made at the time of their original identification were used to verify, enlarge on, or correct the original description or blazon.

It was decided from the beginning that only those objects with probable specific armorial devices would be considered for inclusion in the Ordinary, although borderline cases have been included. It was thought better to be inclusive, and to provide illustrations of objects whose armorial significance is open to question, in order to ensure that nothing which was relevant to the Discussion would be omitted. This is particularly pertinent in the case of the groups of early material (Figs 6–9), but applies throughout. A number of examples employing single charges as ?badges (see p.23 and Fig.25) or for purely decorative purposes were excluded from the Ordinary, as were all non-armorial mounts and fittings originally used for attachment, unless still joined to, or found in close association with, the armorial object they once helped to display (*e.g.* nos **38**, **56** and **105**). A small selection of twelfth/thirteenth-century non-armorial examples of horse furniture is illustrated in Figure 5.

A rough calculation, based upon finds recorded on the county SMR, produced the following estimated breakdown of catagories of horse furniture. Between March 1984 and May 1995 a total of *c.*400 objects of decorative horse furniture were recorded. Of these 160 (40%) could be classed as armorial, 189 (47%) as plain or purely decorative (this number includes attachments for pendants), and the remaining 52 (13%) were unascribable. However, as these figures reflect only what was added to the SMR, other factors, such as a bias towards reporting 'interesting' (*i.e.* armorial or decorated) finds, must be borne in mind.

The following typological discussion of artefacts, and calculations of numbers in the Discussion, are based upon objects drawn and described by the author (Figs 3 and 6–25).

The Ordinary (Appendix 1)

The Ordinary (a dictionary in which arms are listed alphabetically by the charges they contain, pages 34–52) has been arranged in a manner which closely follows that used in the *Dictionary of British Arms* (Vol.1 Chesshyre and Woodcock 1992, xv–xix and Vol.2 Woodcock *et al.* 1996, xi–xvi), which is itself based upon that employed by Papworth (1874). It differs from this notably in two ways: lions are included alphabetically with other Beasts, and are subdivided in the same way (*i.e.* lions rampant do not preceed all other lions), and eagles are treated similarly within the category Bird.

MEDIEVAL ARMORIAL HORSE FURNITURE IN NORFOLK

Figure 1 Map of Norfolk showing the distribution of finds listed in the Ordinary (centred within modern parish)

The Armory (Appendix 2)
A dictionary of arms listed under surnames (pages 52–4). The name of the family or institution is followed by the illustrated catalogue number in bold type. In the case of unillustrated examples the page number within the Ordinary has been given.

List of Illustrated Finds with their Blazons (Appendix 3)
A list of finds with their blazons has been appended in order to assist those readers unfamiliar with heraldic terminology to locate the relevant description for each illustrated artefact (pages 55–8). The drawing number is given first, followed by the blazon (or armorial description) of the arms shown on the object. This is followed by the figure number on which the drawing can be found, and the page number for the description within the Ordinary.

Glossary (Appendix 4)
A glossary of those heraldic terms employed within this volume can be found on pages 59–62.

Conventions
All the objects recorded in the Ordinary are cast in copper-alloy (with one exception, a lead trial-piece, Figure 3, see below, p.4). Metallurgical analysis of a small selection of studs, mounts, badges and related artefacts is presented in Mitchiner (1988, 74–94). They employ a variety of additional methods of manufacture and decoration including engraving, gilding, silvering and *champlevé* enamelling. The presence or absence of these attributes should be clear from reading the blazon, although where small traces of such decoration survive and the evidence has been extrapolated, this is indicated.

The majority of the objects have suffered loss and decay whilst in the ground, and the blazon is often, therefore, incomplete. Additional complications are caused by the tendency of coloured enamels to mutate under certain conditions and change to white or pale green, and also by the presence of a red discolouration. This discolouration is visible sometimes when enamel is missing, and is probably caused by traces of copper oxide produced during the process of enamelling (pers. comm. N. Meeks).

In general, the arms depicted are described as they appear, but if they can be identified with any degree of certainty the missing tinctures are added within square brackets. In the case of poor or wrong execution of arms, which occurs occasionally due to the relatively small scale of manufacture coupled with complexity of design, the probable intention is noted where possible.

The identification of arms has, in the main, been made using a combination of the following volumes: Brault 1997, Chesshyre and Woodcock 1992, London and Tremlett 1967, Papworth 1874, Rye 1913 and 1917, and Woodcock, Grant and Graham 1996.

Each entry in the Ordinary includes the following information (if available) in this order:
1. Illustrated catalogue number, in bold type (the method of ordering and cross-referencing text and illustrations suggested by Goodall and Woodcock 1991 is largely followed here, with the addition of a checklist of illustrated finds with their blazons (Appendix 3)). These numbers differ from those in the original dissertation (Ashley 1999a) as additional finds have been incorporated and the catalogue was subsequently reordered.
2. Blazon (in italics).
3. Shape of field (and description of any decoration surrounding the arms, within brackets).
4. Type of artefact (pendant, mount, stud *etc*.).
5. Form of artefact (shield-shaped, lozengiform, square *etc*., broadly following, with some additions, that proposed in Griffiths 1986b).
6. Notable features (*e.g.* rivet-holes, presence of rivets or of iron pin, and condition).
7. Name of family or institution represented (in capitals), and biographical details.
8. Bibliographic references.
9. Museum accession number.
10. Source of information (all illustrated objects, with the exceptions of nos **6**, **44** and **150**, have been examined in hand by the author, other sources are noted including personal communications, bibliographic and photographic evidence).
11. Site number in the SMR and name of parish (occasionally the names of two parishes if the site in question straddles a parish boundary). Modern parishes have been used here. A distribution map of those finds with secure provenance is given in Figure 1. A loose folding map showing the location of Norfolk parishes is provided in Wade-Martins (1993).

All illustrations are by the author. They are arranged and numbered typologically according to form, function, and, within each classification as far as is possible, chronology, with the exception of those objects shown in Figures 6, 7, 8 and 9, which form two separate and clearly defined early (twelfth/thirteenth-century) groups within the corpus.

METALS

Or Argent

COLOURS

Azure Gules Sable Vert Purpure

Figure 2 Conventions for tinctures. Note: the large, evenly spaced mechanical stipple denoting Or is not to be confused with more naturalistic stippling used to indicate the form of the object illustrated

The cut-off date for the drawing of finds and their inclusion in the Ordinary for the original dissertation, with one exception, fell at the end of November 1998. The author continued to draw all relevant finds after this date and these have been incorporated into this present volume, the cut-off date for these additional items fell at the end of December 1999.

The drawings of artefacts follow standard archaeological conventions (Grinsell, Rahtz and Price Williams 1974, 51–3). The depiction of tinctures follows the conventions proposed by De Petra Sancta in the seventeenth century (Friar 1987, 267–8); these are illustrated in Figure 2.

In the following sections, 'The Finds' comprises an attempt to provide archaeological and art historical parallels to help with the problems of dating armorial horse furniture; and the 'Discussion' attempts to place such horse furniture in its broader historical and armorial context.

Although a number of the arms shown here are readily identifiable (England, de Bohun and Beauchamp for example) others are more problematic and a variety of factors has been taken into account when arriving at an attribution. Therefore, the reader is advised against using this volume as a 'short-cut' to the identification of arms without also consulting published rolls of arms and *The Dictionary of British Arms*[1] to that end.

The Finds

Use

The majority of the pendants (with their suspension-mounts), studs and mounts illustrated in Figures 4–25 were worn on the breast-band, the rear strap, and the brow-band of the horse, sometimes in combination with small bells (see Plate I and Griffiths 1986b, figs 1a–1d). Studs were also occasionally used on stirrup-straps (see page 9). Variant uses, such as in elaborate sets, are discussed in the relevant sections below.

In a small number of the cases noted here alternative uses may be possible, These are suggested where appropriate. The following two examples of the employment of pendants and mounts for uses other than as horse furniture illustrate the degree of caution which must be exercised when identifying such objects.

Firstly, a fragment of a monumental effigy from Blackborough Priory, Norfolk (SMR 3430) which showed a dog at the feet of a lady was exhibited in 1916 (Burlington Fine Arts Club, 28–9). Hanging from the collar of the dog was a small armorial pendant, bearing the arms of Scales, *six escallops*, impaling Ufford, *a cross engrailed* (the sculpture was, unfortunately, destroyed by the *Luftwaffe* during the wartime bombing of King's Lynn Museum).

Secondly, a coat of plate armour from excavations on the site of the Battle of Wisby (1361) in Gotland, bears fleur-de-lis, shell, and shield-shaped mounts of copper-alloy, with engraved linear decoration, that on the shields depicting a set of three related, differenced, arms (Thordeman *et al.*1939, 227–9, fig.206, and plates 32–8).

Examples of medieval enamelled armorial curb bits for horses, from as far afield as France and Sicily (Laking 1922, 161, fig.965), are known from museum collections, although to date, none has been found in Norfolk.

Manufacture

A shield-shaped pendant cast in lead (Fig.3) must be associated with the manufacture of such objects in copper-alloy, as the plasticity of the material employed would argue against any practical use as a piece of horse furniture. Lead models have increasingly been recognised as a part of the casting process, possibly as a replacement for wax in the 'lost-wax' method of casting (East 1986, 1–2). However, the example shown here, being itself cast, probably represents either a trial-piece or a *patron*, a durable master form which would have been pressed into still-damp clay moulds for multiple production (Egan 1996, 92). The presence of this artefact in an area producing an assortment of medieval finds (SMR 34131 Oxborough) may indicate the local manufacture of identical forms in copper-alloy. However none has as yet been found.

All examples of horse furniture included herein are copper-alloy, although at least two examples of iron are known from the county. The first, possibly originally gilded (non-armorial) bifurcated pendant with its suspension stud, was found during the excavation of the fill of a hornwork ditch at Norwich Castle, in association with pottery belonging to the middle of the twelfth century (Ashley forthcoming b). The second example, which appeared to be a pendant, albeit with the remains of an unusual arrangement for suspension, has lost whatever original decoration it may once have had, and is shown in Figure 4.

Figure 3 Lead trial-piece or *patron* for a shield-shaped pendant. Scale 1:1

Figure 4 Iron shield-shaped ?pendant (SMR 31559 Sporle-with-Palgrave). Scale 1:1

Non-armorial Horse Furniture

A small selection of non-armorial horse furniture of twelfth/thirteenth-century date, and of some relevance to the following discussion of early armorial horse furniture, is shown in Figure 5. Pendants nos **1** and **3** were originally gilded and possibly ?decorated, but any decoration there may have been has worn away. Pendant no. **1** has an early shield shape (see below) as probably pendant no. **2** also had. Pendant no. **2** displays some of the characteristics of the group of armorial pendants shown in Figure 6 (with the addition of traces of ?niello in the engraved decoration), and has a decorative motif (the acanthus leaf) which is closely paralleled by an excavated example from Northolt manor, Middlesex, found in a context dated to *c.*1225–1300 (Hurst 1962, 290–1, fig.76, no. 24). A similar leaf motif can be seen on a tenth/eleventh-century openwork pendant from Baden-Würtemberg, Germany (Wamers 1987, 108, fig.8, no. 2). Pendant no. **4** has a simple segmented design, and pendant no. **5** an unusual elaborate 'm'-shape with stamped decoration. Pendant no. **6**, of foliate form, shares many characteristics with the second group of early armorial horse furniture described below (see p.7 and Figs 8 and 9). Mount and suspension-mount nos **7** and **8** also employ foliate decoration.

Figure 5 Twelfth/early thirteenth-century non-armorial horse furniture. Scale 1:1

1	Pendant (SMR 34103 Scarning)	2	Pendant (SMR 33091 Felthorpe)
3	Pendant (SMR 17940 Costessey)	4	Pendant (SMR 21617 Fransham)
5	Pendant (SMR 1071 South Creake)	6	Pendant (SMR 10801 Quidenham)
7	Mount (SMR 1073 Bacton)	8	Suspension-mount (SMR 31934 Aylmerton)

Early Examples of Armorial Horse Furniture

Two distinct early groups of ?armorial horse furniture have emerged from objects recorded in the Ordinary. The first group (Figs 6 and 7), possibly dating from the second quarter of the twelfth to the early thirteenth century, comprises mounts, pendants, some with 'kite-shaped' (certainly *ante* c.1300, pers. comm. C. Gravett, the kite-shaped 'long shield[as depicted on seals at least, was] becoming outmoded by the 1130s', Heslop 1984, 317, no.371) and 'almond-shaped' shields, nos **1–5** (also early, see Neubecker and Brooke-Little 1997, 76–7), and suspension-mounts. All of these (with the exception of no. **18**) employ engraved and stamped decoration and gilding. The usual absence of cast decoration and enamelling, and the general thinness of the metalwork all contribute to an early 'feel' to these artefacts.

The mount bearing the *checky* arms of Warenne (no. **1**) was discovered during recent excavations on the site of Norwich Greyfriars, in a pre-friary ?quarry pit of possibly twelfth-century date, the finds from which were largely residual (Ashley forthcoming a). The family of Warenne, originally from Varennes in Normandy, has early and important associations with Norfolk. William I granted Castle Acre in the west of the county to William de Warenne, one of his most loyal supporters, sometime before the Domesday survey. At the time of the survey (1086) Warenne was in possession of 138 holdings in 24 of the 33 Norfolk hundreds (Brown 1984, entry no.8). William de Warenne was subsequently created Earl of Surrey at Easter 1088 after supporting William II against Odo, Bishop of Bayeux and Robert, Count of Mortain. The country house and castle built at Castle Acre by William,

Figure 6 Twelfth/early thirteenth-century pendants, mount and suspension-mounts. Scale 1:1

Figure 7 Twelfth/early thirteenth-century pendants, mount and suspension-mount. Scale 1:1

and continued by his son and grandson 'are witness to the political power and to the importance which they attached to their Norfolk holdings' (Coad and Streeten 1982, 139–143).

Pendants nos **6**, **7** and **9–16** (Figures 6 and 7) have stamped and gilded decoration of similar type to that employed on a pair of almost identical openwork pendants of elaborate octofoil form with a pierced cross overlying a pierced saltire, from excavations on the castle of Rubercy, Normandy. These pendants from Normandy date to the second half of the twelfth century (D'Onofrio 1994, 380–1, nos 13–4).

The device of a star radiating from a central boss is shown on nos **6**, **7** and **10–13**. Pendants nos **11** and **12** are almost identical to an example from Lode, on the Cambridgeshire fen edge (Taylor 1985, 36–7, fig.15, no.206). Parallels for these can be found in examples of shield decoration common on equestrian seals from the middle of the twelfth century (Ailes 1990, 4). The radiating star device may have a purely formal or prosaic origin derived from the method of attaching the boss to the shield. However, it is worth speculating on an alternative origin and possible symbolic meaning for this device. As depicted on horse furniture in particular it bears some resemblance to the comet (minus tail) shown in the Bayeux Tapestry and identified by the inscription *STELLA* (Wilson 1985, plate 32). This comet ('Halleys' comet'), which first appeared on 24th April 1066 and blazed in the night sky for a week (Garmonsway 1953, 194–5), was intimately linked with the Norman conquest in contemporary imagination as far afield as Italy, Poland and Anjou (Freeman 1870–9, vol. III, note N, 645–50 and Douglas 1969, 181, footnote 1).

Although purely hypothetical, it seems plausible that this renowned heavenly portent was retained in (Anglo-Norman) folk memory as a signifier of good fortune, and was as such a popular choice for the decoration of such things as shields and harness.[2]

There are two pendants which depict beasts or monsters (nos **17** and **18**). The animal shown on no. **17** is stylistically similar to that on a pendant discovered on the excavations in Southampton (Harvey 1975, 254 and fig.240, no. 1708) which has been dated to *c*.1200–50. Pendant no. **18** displays a ?wyvern, has cast decoration, and possibly provides the earliest example of enamelling in this corpus. The decoration, although less sophisticated, is reminiscent of that which appears on a series of medallions on two Limoges enamel coffrets, dated to *c*.1110–30 (Taburet-Delahaye 1996a, 78–82 and Taburet-Delahaye 1996b, 83–6, a–j). However, a usual lack of enamelling, and therefore of tinctures in this first group of early horse furniture, does introduce an element of doubt as to whether some of the devices depicted should be considered 'pseudo-armorial' or 'proto-armorial' (see Discussion below, pp. 28–9).

This uncertainty also applies to the second group of early objects (Figs 8 and 9), in some ways more so, as the depiction of beasts and monsters used as charges clearly derive from the Romanesque tradition. These items, probably dating to the second half of the twelfth or thirteenth century, are generally small in scale, have cast decoration, are often gilt overall, although some of the later ones are enamelled, and are of either square or circular form. The style of lettering used on three of the pendants (Figs 8 and 9, nos **24**, **35** and **36**) conforms broadly with this date range (*cf.* the late twelfth-century seal of Peter Corbucion in Harvey and McGuinness 1996, 80, no. 71).

Figure 8 Twelfth/early thirteenth-century elaborate set.
Scale 1:1

The combination of lion and fleurs-de-lis shown here on pendants and mounts (nos **20, 22–3, 25** and **27–8**) could, at first glance, be mistaken for later (post-1340) allusive arms, such as those illustrated in Figure 21, and discussed on page 23. They do, however, appear to sit more happily within the context of earlier use of similar devices. The fleur-de-lis first appears as a single flower, held in the King's right hand, on the seal of Robert I, the Pious, in *c*.997, and continues to be used on French royal seals from that time onwards (Hinkle 1991, 5 and pl.3, a). In England, coins showing Henry I wearing a crown decorated with fleurs-de-lis appear in *c*.1106–8 (Archibald 1984, 325 and 330 no.411). The depiction of a lion within a double tressure fleury counter fleury (to which the annulet fleury, seen here, bears some passing resemblance) is first used, as the arms of Scotland, on a seal of Alexander II in 1215 (Hinkle 1991, 171, n.1).

Close parallels for the beasts and monsters employed on this group of finds can be found in Foot (1984, 344 and 346), who illustrates a series of decorative tool impressions from Romanesque book bindings, dated to *c*.1185. These include a wyvern (346, ill. no. 2), a lion passant to sinister (ill. no. 6), and two griffins combatant flanking a staff fleury (ill. no. 20). The square pendant with lions flanking a staff fleury shown in Fig.9, no. **29**, can also be paralleled by a similar scene shown on a circular pendant from Old Sarum. This pendant has been placed in the late twelfth or early thirteenth century on the basis of a comparison with late twelfth-century 'heraldic' compositions on textiles such as the Hubert Walter dalmatic in Canterbury (Stratford 1984, 278 no.295)[3].

Those examples presented together in Figure 8 comprise an elaborate set, found scattered within a field in the parish of Sporle with Palgrave (SMR 1058). The rivet-holes at the foot of nos **20** and **22**, and which do not appear to be secondary (traces of gilding are present within the holes), suggest something more complicated than the usual suspension-mount with pendant arrangement, although what this originally comprised is uncertain. An example of elaborately linked horse furniture, albeit post-1340 in date, is given in Prideaux (1911, 234 and fig.6), who suggests in this case its use on a bridle rein.

Lastly, an elaborate pendant, no. **37**, which displays many of the physical and decorative characteristics of this group of early objects, combined with distinctive animal-head terminals which clearly originate within the twelfth century (Stratford 1984, 250–1, *cf*. no. 252). This pendant was found on the surface of a field within *c*.700 metres of the probably twelfth-century motte and bailey castle of the de Ferrers (and later the Warenne) family at Wormegay (Margeson 1994a, 29–30).

Shield-shaped Pendants, Studs and Mounts

Overwhelmingly (and predictably) the largest class of armorial horse furniture, shield-shaped pendants (Figs 4–6 and 10–16), comprise 81 (34%) of the 241 drawn examples. When other shield-shaped fittings (studs and mounts) are included this number is increased to 114 (47%). An examination of earlier finds in the SMR and included in the Ordinary will confirm this trend.

Those pendants, studs and mounts for whose arms it has been possible to suggest a *terminus ante quem* are listed here. The number of the illustrated artefact is followed by the suggested date, family name and reason for end date for arms, from Brault 1997 unless otherwise stated, and more fully referenced in each relevant entry in the Ordinary:

Pendants, nos **46**, 1342 (MOIGNE, ?line extinct); **49**, 1298 (TIPTOFT, change of arms); **52**, 1342 (MOIGNE, ?line extinct); **68–9**, 1372 (BOHUN, line extinct, Burke 1883, 57–8); **72**, 1312 (WEYLAND, change of arms); **80–1**, 1372 (BOHUN, line extinct, Burke 1883, 57–8); **82**, 1316 (MONTAGU, change of arms); **90**, 1338 (BADLESMERE, line extinct, Burke 1883, 18–19); **96**, 1330 (BAYNARD, ?line extinct); **97**, ?1333 (DARCY, change of arms); **103**, *c*.1327 (ENGLAND, label for eldest son of King).

Studs and mounts, nos **122–4**, 1372 (BOHUN, line extinct, Burke 1883, 57–8); **126**, 1311 (BINGHAM, ?line extinct); **130**, 1316 (LINDSAY, forfeited lands); **144**, 1297 (FITZJOHN, line extinct, Burke 1883, 208–9).

The arms of England, *Gules three lions passant guardant Or* (post-*c*.1198), are excluded from the list. Although these arms are usually shown quartered with

Figure 9 Twelfth/early thirteenth-century pendants and mount. Scale 1:1

those of France post-1340, this date cannot be used as a *terminus ante quem*, as they may have been used on individual pendants, studs or mounts in conjunction with others bearing the French lilies after this time. One such pendant, no. **38**, which bears the three English lions and has a simple attachment stud, is similar to another found on excavations on Caergwrle Castle, Clwyd (Courtney 1994, 113–4, fig.15, no. 12).

Pendant no. **57** shows England impaling ?Wake. This coat is most unusual as there would appear to be no connection, either of blood or marriage, between the Kings of England and the family of Wake. A possible motive for this impalement is suggested by reference to earlier discussion of an enamelled coat in the museum at Reggio Emilia, Northern Italy, where the arms of England have been quartered with those of Valence (Wagner 1954). Although this object is now considered to have been faked by the nineteenth-century anarchist and forger Louis Marcy (pers. comm. John Cherry, *cf*. Campbell 1990), the arguments proposed for the unusual marshalling of arms remain pertinent to the England/?Wake impalement. It had been suggested that the quartering on the Reggio Emilia enamel was perhaps intended as a mark of gratitude to the king for a knighthood (Adam-Even 1954), or an indication of the special regard in which the bearer was held (Holyoake 1954). This genuine example, displaying England impaling ?Wake, perhaps commemorates the rehabilitation of Baldwin de Wake, who rebelled against the king, was captured and subsequently pardoned.

Pendants nos **117** and **118** were found with rectangular strap-end no. **119** and probably comprise part of a set. Strap-end no. **120** (found with lozengiform stud no. **165**, Fig.18) is included here for comparative purposes.

That many of the shield-shaped studs shown here (Fig.15) would have originally been attached to leather harness-straps or reins is demonstrated by the survival of roves on nos **125** and **133**, and both leather and roves on nos **137** and **138**. However, plain shield-shaped studs used in combination with bars can also be seen depicted on the shield-strap of the recumbent effigy of Gilbert Marshall, fourth Earl of Pembroke (d.1241) in the Temple church of St Mary, London. Similar shield-shaped studs, attached to a leather strap of uncertain use, and manufactured in tin rather than copper-alloy, have been found on recent excavations in London (Egan 1991a, fig.126, no. 1087).

The pelleted decoration on the small shield-shaped stud, no. **121**, can be paralleled by that appearing on late fourteenth/early fifteenth-century lozengiform, circular and 'S'- shaped studs and mounts of lead/tin from London (Egan 1991b, 244–246, fig.157).

Those examples of studs with longer shanks such as nos **128**, **130**, **131** and **132**, may once have been attached to an iron stirrup and stirrup-strap as discussed by Griffiths (1989, 1 and 3, nos 4a and 4b). The shank would have originally passed through the looped stirrup strap and the top of the iron stirrup to provide additional security. A shield-shaped stud, indistinguishable from many illustrated here, was found on excavations on the late thirteenth/early fourteenth-century dock at Baynards Castle (Wilmott 1982).

Figure 10 Shield-shaped pendants. Scale 1:1

Figure 11 Shield-shaped pendants. Scale 1:1

Figure 12 Shield-shaped pendants. Scale 1:1

Figure 13 Shield-shaped pendants. Scale 1:1

13

Figure 14 Shield-shaped pendants, suspension-mount, lobed rectangular pendant and rectangular strap-ends. Scale 1:1

Figure 15 Shield-shaped studs. Scale 1:1

Figure 16 Shield-shaped mounts. Scale 1:1

This stud is set into an iron bar which has been bent into an 'm' shape for an unknown purpose, although use as a brooch has been suggested. It seems probable that both this example and another of similar form with integrally cast shield and bow, and an iron pin (Nelson 1940, 387), have some association with horse furniture.

The stud bearing an exceptionally long shank (no. **139**) may have been hammered into wood, perhaps part of a saddle or of a harness for draught horses (*cf.* Griffiths 1989, 1 and 3, no. 36). These alternative functions for shield-shaped studs may also be applicable to some of the other forms of stud listed below.

Studs bearing variations on the arms of Bohun (nos **122–4**) and of England (nos **127**, **128** and **131**) can be paralleled by similar examples in Goodall and Woodcock (1991, fig.13, no. 12 and fig.14, no. 21), and in Griffiths (1995, fig.53, nos 77, 78 and 80).

The large mount (Fig.16, no. **146**) displaying the arms of Felbrigg (of Felbrigg, Norfolk), may once have been fixed to the saddle of a horse in a similar manner to that shown in a mural of St George, *c.*1450, in St Gregory's church, Norwich. Shields of this size could equally well have been part of some other object, perhaps even a tomb or monument (Griffiths 1989, 1–2). Large shield-shaped mounts are also occasionally shown on monuments as being attached both to female attire and to the camail of knights (Armstrong 1912, 192).

Lozengiform Pendants, Studs and Mounts

Arms are often depicted upon lozengiform fields in the Middle Ages, there being no exclusively female use of the lozenge at this time. When Chaucer writes in 1383 of heralds 'with crounes wroght ful of losenges' he is interpreted by Wagner (1978, 71 and 74) as meaning shields, the terms being regarded as almost interchangeable. A well known example of a contemporary object with enamelled arms on lozengiform fields is the Valence Casket of *c.*1300 (Marks and Payne 1978, 20–21, no. 15). Lozengiform armorial horse furniture is certainly not uncommon, and examples are illustrated in many of the papers cited in this volume, for example, one such pendant, datable to between *c.*1340–1405 by its arms, quarterly France Ancient and England, is given in Hemp (1936, 292–3, no. 4).

Of those lozengiform pendants shown here (Fig.17), no. **150**, with its crudely inscribed *cross potent* looks early, but as this is one of the three objects redrawn by the author from earlier drawings in the SMR, and not examined in hand, little more can be said of it.

As is the case with many of the other illustrated groups of horse furniture, some of the examples shown may be purely decorative, *e.g.* the birds on nos **151** and **166** (Fig.18), the fantastic monsters on nos **154** and **155**, the head of a king on the elaborate lozenge no. **163** (of similar form to an excavated thirteenth/early fourteenth-century example from Aberdeenshire, shown in Murray and Murray 1993, fig.42, 207), and the estoiles on nos **168** and **169**. Those examples bearing monsters (nos **154** and **155**) can be paralleled by similar pendants cited by Cherry (1991, 22 and fig.3, no. 15), who also gives a useful list of five other horse pendants and two medieval tiles which employ this design. A further pendant bearing this charge, described as a 'gryllus', is figured in Goodall and Woodcock (1991, 246 and fig.14, no. 30).

Pendants **159** and **160** comprise a pair found together on the same site. Stud no. **165** was found near to strap-end no. **120**, and could perhaps be paired with it although there is some element of doubt concerning the original orientation when in use, and therefore whether either or both are *barry* or *paly*. Lastly, the pendant (no. **162**) displaying *[Or] a lion rampant queue forchee Vert a bend company [Argent] and Gules overall* appears to be a coat for Sutton. This coat combinines a lion rampant queue forchee and a (lion rampant with a) bend company, both from known coats for this family, to form a previously unknown variation on them.

Figure 17 Lozengiform pendants. Scale 1:1

Figure 18 Lozengiform studs and mounts. Scale 1:1

Square and Rectangular Pendants, Mounts, Suspension-mounts and Studs

Square pendants of the late thirteenth–early fourteenth centuries are relatively uncommon, and these examples perhaps date to the early rather than late thirteenth century. An aquamanile of *c.*1200 from Lorraine shows square pendants suspended from both bridle and breast-band (Grinder-Hansen 1992). It may be of some significance that of the five pendants illustrated here (Fig.19, nos **170–4**), four have possible continental armorial connections; no. **171** bears the arms of the Duke of Guyenne, no. **172** the arms of ?Normandy, no. **173** has an 'odd, not to say bizarre, arrangement of the charges [which] occurs only in a small armorial group ... mainly, if not exclusively, connected with Normandy', in this case belonging to the family of Trubleville (for a discussion of two other pendants bearing the same arms, see London 1949b, 204–6, and Cherry 1991, 20–1), and no. **174** sports the cross of Toulouse (see below).

The rectangular mount (no. **179**) also bears continental arms, those of France and Castille, shown in a way which may allude to Alphonse, Count of Poitou (d.1271) and his wife, Blanche of Castille. An early fourteenth-century pendant which displays two shields side-by-side in similar manner can be found in Alexander and Binski 1987 (258, no. 157), the arms depicted being those of England and of Cornwall. Mounts **175**, **176** and **177** display variations on the cross of Toulouse, of similar form to those discussed in London (1958, 359–60, fig.3) and shown powdering the surcoat of the engraved effigy of Simon de Montfort (d.1218), on his tomb-slab in Carcasonne, France (Goodall 1998, figs 1 and 2).

The larger of the two studs (no. **182**) appears to be early, the style in which the dragon is depicted perhaps belonging to the middle of the thirteenth century, although it is very different in feel to those twelfth and thirteenth-century groups discussed above (pp.5–8), and is possibly more decorative than armorial. Stud no. **181** may be a badge (see below, p.23).

Circular Pendants, Studs and Mounts

Circular pendants, studs and mounts (Fig.20) are not uncommon, and they are shown in many published collections of horse furniture.

Pendants nos **183** and **184**, which appear to be early, have crosses of Toulouse similar to those on the square pendant and three mounts discussed above. Pendant no. **187**, depicting an owl, can be closely paralleled by an example from London Wall, although in this case the owl is *Gules* rather than ?*Argent* (Ward-Perkins 1940, plate XXI, no. 4).

Stud no. **189** was found on recent excavations within the south bailey of Norwich Castle, in the fill of a well dated to no later than the early sixteenth century. The finds, which appear to be largely residual, included more (non-armorial) horse furniture and other artefacts relating to harness, armour and weaponry, and may indicate the presence of a repair workshop on the site (Shepherd-Popescu forthcoming). Stud no. **191** is similar to another in Cherry (1991, 23 and 27, no. 22) with a crowned R, to which he gives a fifteenth-century date, both of these examples are perhaps more likely to have been in use as badges rather than as arms.

Mounts **194** and **195** are similar in execution to three examples shown in Hemp 1936 (293–4, nos 5–7), which also employ leaves to fill the space between shield and border, and which have been dated broadly to the fifteenth century.

Figure 19 Square and rectangular pendants, mounts, suspension-mounts and studs. Scale 1:1

Figure 20 Circular pendants, studs and mounts. Scale 1:1

20

Figure 21 Trefoil, quatrefoil and elaborate quatrefoil pendants. Scale 1:1

Figure 22 Elaborate quatrefoil pendants, stud and mount. Scale 1:1

Trefoil, Quatrefoil and Elaborate Quatrefoil Pendants, Stud and Mount

The trefoil pendants shown (nos **197** and **198**) in Figure 21 are of a comparatively rare type. Both figured here bear the arms of the Bishop of Ely. They can be paralleled by a similar trefoil pendant displaying *three crowns (2,1)* in Roach-Smith (1868, 52, no. 8).

The quatrefoil form seems to be a late development, as at least ten (possibly twelve) of the twenty-five drawn examples display arms which are allusive for England and France (nos **203–5**, **207–13** and ??**214** and ?**215**). These pendants are most likely to have been made after 1340, when the fleur-de-lis of France were quartered with the lions of England, although Dunning (1965, 53 and fig.1) illustrating an almost identical example to no. **207**, suggests an earlier association with Isabella of France, wife of Edward II. Goodall and Woodcock (1991) show a similar pendant to nos **208–13**, but the description has been omitted from their ordinary. Two further examples are shown in Beresford (1975, 93–4, fig.44, no. 33), and Rahtz (1969). The latter, bearing a lion passant guardant, misidentified as a 'winged gryphon or other mythical animal', was found in an excavated context dated to *c*.1425–1521 (Rahtz 1969, 87 and 90, fig.49, no. 106). Pendant no. **214** is included here as, although possibly entirely decorative, it displays stylistic traits in common with this group of allusive finds, such as the fleurs-de-lis radiating from a central field.

A selection of charges on quatrefoil and elaborate quatrefoil pendants from London (Griffiths 1995, fig.49) includes a griffin, almost identical to those on nos **201** and **202** (field differently tinctured), and three crowns of similar type to those on trefoil pendants nos **197** and **198** (see above, although the arrangement is reversed, *three crowns 1.2*, rather than *three crowns 2.1*, and the enamel is missing).

The elaborate quatrefoil mount no. **223**, shown in Figure 22, is unparalleled, and, although similar in form to those quatrefoil pendants illustrated here, could be derived from something other than horse furniture. It demonstrates the way in which the space surrounding the shield was sometimes filled, most often on seals (*cf.* Ellis 1978, 7 and pl.3, no. P76), with beasts or monsters, which were later to evolve into true heraldic supporters.

Octagonal and Elaborate Pendants

Octagonal pendants, illustrated in Figure 23, appear to be largely confined to the eastern counties of England (pers. comm. N.G.). Pendant no. **226**, displaying *Quarterly 1 and 4 Azure semy-de-lis Or (France Ancient) 2 and 3 Gules three lions passant guardant Or (England)*, must date to somewhere between *c*.1340 and 1405 as indicated by the arms, and, one suspects, the others of similar form shown here (nos **224**, **225**, and **227–9**) also belong to the late fourteenth century.

A number of the finds illustrated here have devices or charges of debatable armorial significance, but have been included precisely for that reason. The head of Christ on no. **224** is unusual, but is identical to another on a ?mount, described as being from the centre of a ?bowl (*Norfolk Archaeol*. 7, 349), on display in Norwich Castle Museum. Possibly it was once employed as an armorial device, but it is more likely to have been of entirely religious significance. Similarily other pendants depicted here, nos **230–5**, may or may not be armorial, although the two which bear *an eagle displayed*, nos **236** and **237**, clearly are.

Pendants **231–2** and possibly even **233–5**, may have some association with the group of early finds shown in Figures 8 and 9, but are probably best included here pending further investigation.

Elaborate Sets

Rectangular banners such as those shown in Figure 24 (nos **238–40**) may originally have been attached to a device similar to that in Cherry (1991, fig.2, no. 12), that is, an iron rod projecting vertically from the centre of a copper-alloy mount with two rectangular openings, probably for leather straps to pass through. The shield-shaped and lozengiform 'banners' figured here, nos **241–3**, would have been supported by a similar arrangement, although the vertical rod would have been copper-alloy, like the one which survives attached to no. **242**. A circular example from London, complete with mount, is shown in Ward-Perkins (1940, fig.40, no. 2), whilst another, from Mere Down, Wiltshire, can be dated to between 1351–61 (Shortt 1951).

The hooked mounts, nos **244–5**, were probably once attached to harness-straps.

The small elaborate lozengiform pendant, no. **246**, is almost identical to those belonging to an elaborate set shown in Ward-Perkins (1949, fig.2), and it is likely that it was once part of such a set, as also, possibly, were some of the other pendants illustrated in this corpus. Larger lozengiform examples forming part of an elaborate set are depicted in *A Guide to the Medieval Room* (British Museum 1907, 55, fig.53). The use of elaborate arrangements on saddles and head-stall mounts, such as those described above, is discussed and illustrated in Ward-Perkins (1949).

Armorial Badges

It is sometimes impossible to differentiate between arms bearing single charges, and devices which have been abstracted for use as a badge, *e.g.* those finds bearing a single fleur-de-lis (nos **181** and **234**), which may refer to the post-1340 English claim to France, or be entirely personal, or entirely decorative.

As Fox-Davies (1950, 456) states '...we are always in uncertainty whether any given device was merely a piece of decoration borrowed from the arms or crest, or whether it had continued usage as a badge'.

Badges have, when positively identified, been excluded from the Ordinary, and from the accompanying illustrated catalogue, although a selection of them is shown in Figure 25. The lion (no. **1**) is probably that of England (*cf.* leaden examples of single lions passant guardant as badges in Spencer 1980, 28, ills.123–7). At least two other copper-alloy lion-shaped badges have been found; a mount from Croxton (photo NCM) in the form of a lion rampant, the space between body and tail forming two ?rivet-holes, and a pendant lion rampant to sinister, gilded and decorated with stamped annulets, from Keswick (SMR 28665). The key ensigned with a crown displayed on the circular mount (no. **5**) is that of Poynings of Sussex.

The knot (no. **7**) belongs to the Staffords (the Stafford knot also occurs on a pendant found in Riddlesworth, SMR 6110). The mount (no. **6**) is difficult to interpret as its

Figure 23 Octagonal and elaborate pendants. Scale 1:1

Figure 24 Banners, rotating shields and lozenge, straphooks and pendant from elaborate set. Scale 1:1

Figure 25 Armorial badges on pendants: **1** Lion (SMR 33232 Walpole St Peter); **2** Eagle (SMR 30192 Roudham);
3 Eagle (SMR 28738 Sporle with Palgrave); **4** Escallop (SMR 30761 East Rudham)
on mounts: **5** Key ensigned with a Crown (SMR 3579 Grimston); **6** ?Cope (SMR 33062 Wymondham)
and on stud: **7** Stafford knot (SMR 33391 Besthorpe). Scale 1:1

enamel is missing, but it appears to depict some kind of cope or vestment, and is therefore likely to be religious, as is the escallop (no. **4**), a common badge of pilgrimage (Bellew 1957), although this shell was widely used, by Dacre amongst others (Fox-Davies 1950, 299–300). Excavated examples of these shell-shaped pendants and pendant mounts have been found in late twelfth-century contexts at Castle Acre castle, Norfolk (Coad and Streeten 1982, 238–9, fig.44, nos 36–7), at North Elmham, Norfolk (Goodall 1980, 503 and fig.264, no. 36) and Thrislington, County Durham (Austin 1989, 134–5, fig.57, no. 11).

The eagles (nos **2** and **3**) are unidentified. A somewhat similar eagle pendant was found in excavations at Northolt manor, Middlesex, but the date range of the context is too great to be of use (Hurst 1962, 290–1, fig.76, no. 23). It is possible that both the eagles and the lion illustrated here had some association other than with horse furniture; one is reminded of livery collars for example (*cf.* the lion badge in Smith 1990, 247 and the boar in Tudor-Craig 1973, pl.66). Openwork lion badges are also illustrated in Mitchiner (1988, 79, nos x121–x123).

Discussion

Origins and Development

The birth and development of armory was intimately related to the rise of the *milites*[4] (or horse-soldiers), whose origins lie in the lands of the Western Franks sometime in the 970s (Crouch 1992, 120–2 and 224–6), and their later transformation into medieval landed knights. The debarkation of these horse-soldiers and their lords onto an English shore in the autumn of 1066 brought with it the first indications of what would later become *the* system of noble identification and display (Wilson 1985, 223 and pl.70; Crouch 1992, 220–2). It seems fitting, therefore, that this opening phase in the wider Norman aristocratic diaspora should be signalled at the beginning of the corpus by a twelfth-century mount bearing the arms of Warenne (Fig.6, no. **1**). The *checky* shield of Warenne is ultimately derived from the counts of Vermandois, themselves descendants of Charlemagne (Crouch 1992, 222–3 and 225–6; Wagner 1956, 14 and 15).

The origins of armorial horse furniture may lie sometime in the second and third quarters of the twelfth century. Decorative horse furniture (with the possible exception of an occasional studded leather breast-band) is absent from the Bayeux Tapestry (*ante* 1082), which is 'remarkable in providing a vivid evocation of the first recorded cavalry action in the north', and which illustrates such detail as 'The heavy saddles, long stirrup leathers, the spurs, the couched lance and the kite-shaped shield' (Wilson 1985, 226). However, decorative trappings in the form of pendant crosses suspended from the breast-band (or peytrel) of a horse, are shown on a tympanum above the south door to the church of St George, Fordington, Dorset (Plate I). This tympanum is dated by Newman and Pevsner (1972, 180) as 'hardly later than 1100', and is considered by Riley-Smith (1995, 80) to have been carved not long after the Battle of Antioch in 1098, which event it may depict.

The use of decorative horse furniture towards the end of the eleventh century is indicative of wider cultural developments. Graham-Campbell (1992, 78) writes that: '...in both Normandy and England, it was not just the quality of the mount [horse] that mattered — or that reflected its owner's status — but also that of the horse's equipment. Horse-trappings, as much as a man's weapons, had become status-symbols...'.

Much evidence of a similar nature to that provided by the Fordington carving exists in other parts of Europe, and also in those lands touched by the Crusades. For example, in the Church of Our Lady, Dendermonde, France on an early twelfth-century carved Tournai font depicting Saul on the road to Damascus, a series of circular pendants are shown suspended from the breast-band of the horse (Nicolle 1999, 31, plate, bottom left). In Modena, Northern Italy, there is a stone carving on the archivolt of the north door of the cathedral, which illustrates the rescue of Guinevere by King Arthur and his knights. This carving shows circular pendants suspended from the breast-band on two of the horses, and dates from the first half of the twelfth century (Higham and Barker 1992, 158–61, plates

Plate I Detail from a late eleventh/early twelfth-century tympanum showing St George mounted on a horse displaying harness pendants, church of St George, Fordington, Dorset (*Photo: SJA*)

5.9a and b). Another piece of twelfth-century sculpture, this time a capital, from Estella, in Spain, has crescent-shaped pendants worn in a similar manner, and which perhaps anticipates, or possibly represents, the early use of this device in true armory (Barber 1978, 24, plate, bottom of page). Shield-shaped pendants make an appearance on the mounts of early twelfth-century cavalry depicted on a carving on the west front of the church of San Zeno, Verona, Italy (Nicolle 1999, 52, plate, top right)

From the end of the eleventh century onwards, military expeditions — Crusades — led by a European noble elite were mounted against the Islamic domination of the Holy Land. This resulted in increased contact and cultural exchange with the Byzantine Empire, the East and the Islamic world. With regard to the early development of arms in the Holy Land, it has been suggested that, at the time of the First Crusade, sub-divisions within the army such as a *Conrois* (a unit of approx. 20–40 men) were indicated by the use of pre-heraldic patterns displayed on shields (Ailes 1992, 14 and Nicolle 1999, 25–6). The wearing of badges and emblems with Christian significance must also have prompted similar use of other more secular devices. Count Helias (d.1100) father-in-law of Fulk V, Count of Anjou (later King of Jerusalem),

Plate II Romanesque carving of a mounted knight spearing a dragon, in the church of St Margaret, Swannington, Norfolk. The carving displays proto-heraldic geometric patterns: the Knight's surcoat is *checky*[5], his shield *bendy* and *chevrons* decorate the upper edge of the stone. A stylised ?Eagle displayed appears behind the knight (*Photo: SJA*)

speaks, at the onset of the first crusade, of having the Christian cross 'engraved on my shield and helmet and all my arms; on my saddle and bridle also I will stamp the sign of the holy cross' (Orderic Vitalis, v.231, see Ailes 1982, 37). Coins of Bohemond I, Prince of Antioch (1098–1111) show a mounted knight with lance and kite-shaped shield, and pendants suspended from the breast-band of his horse (Rowley 1999, 139, fig.67b). Similar representations are present on the twelfth-century seals of William of Bures, Prince of Galilee and Bohemond III, Prince of Antioch (Runciman 1998, plate VI).

Early English personal seals showing equestrian pendants include those belonging to William de Roumare, Earl of Lincoln, which is dated to the middle of the twelfth century (Ellis 1981, 91, no. P1970, and plate 27) and Roger de Mowbray, of *c*.1155 (Harvey and McGuinness 1996, 47, no. 41). Pendants are shown with their suspension-mounts on the Second Great Seal of Richard I, of *c*.1195–8 (Nicolle 1999, 58, plate, top left). They also appear in manuscript illustrations, *e.g.* on horses in an initial of *c*.1130 (Kauffmann 1975, 61 and ill.40), and in battle scenes involving mounted knights of the mid-twelfth century (Kauffmann 1975, 104–5 and ill.219).

Some evidence for the early use of arms on horse furniture has emerged during this survey. Although displaying none of the colours of heraldry, a number of the twelfth and early thirteenth-century pendants and mounts (Figs 6 and 7) employ devices whose shape does not appear to be determined by the form of the artefact upon which they are depicted. These devices are unlikely to be purely decorative, but must have had some other, armorial, meaning, *e.g.* the fret on no. **9**, and the barry field on no. **14**.

This early heraldry and proto-heraldry, involving geometric devices and orderly divisions of the shield (as shown on the Romanesque carving in the church of St Margaret, Swannington, Norfolk, Plate II), is discussed briefly in Ailes (1990). Ailes states that according to the evidence of seals, early arms were either geometric or consisted of a single charge (although seals were at this time largely the preserve of the upper echelons of society, Ailes 1990, 6). The decoration present on early armorial horse furniture would appear to confim this thesis (with the addition of paired beasts, see Figs 6, 7, 8 and 9 and below), whilst perhaps providing confirmation that this was also the case further down the social scale. The division by Ailes (1990, 2) of the development of heraldry into three overlapping phases is helpful here. These phases are: 'decorative' (late eleventh-century), 'proto-heraldic' (early twelfth-century, and from the 1130s and 40s animal charges in classic poses) and 'heraldry proper' (inherited arms, second quarter of the twelfth-century). Sandy Heslop argues convincingly that these early geometric patterns (and animal charges) were ultimately derived from imported woven cloths (Heslop forthcoming, see also Davies 1979, 120–4 and Davies 1984). Parallels can also be found in contemporary architectural decoration. This simple table (below) gives a selection of architectural motifs, their (broad) armorial equivalents, place of origin and typical examples, and likely date of first use:

Billet	(*Billet*)	(Norman) Caen	post 1060
Chip Carving	(*Lozenge*)	(Anglo-Norman) Norwich, Durham	*c*.1070–80
Chevron	(*Chevron*)	(Anglo-Norman) Norwich, Durham, Lincoln	*c*.1100
Nutmeg Grater	(*Gyronny*)	(Anglo-Norman) Westminster	*c*.1100
Boule	(*Pellet*)	(Anglo-Norman) Wymondham, Exeter	mid twelfth century

Twelfth-century architectural polychrome painting, such as that in Kempley Church, Gloucestershire, also employs a similar range of decoration (Zarnecki *et al.* 1984, 51, colour plate, top of page). Further support is lent to the analogy by the identification of architectural origins for at least two of the heraldic terms listed above, *Billet* ('tree trunk') and *chevron* ('rafters joined together to form a gable'), by Brault (1972, 129 and 142). Whatever the true sequence of stages in the evolution of early arms, there was at least some form of common and shared language of ornament. This appears to have had a considerable influence on the development of heraldry at the beginning of the twelfth century. As Brault writes '...the existence in medieval painting and sculpture of prototypes for the principal elements of heraldic art is undeniable...' (1972, 5)[6].

The Romanesque beasts and monsters which adorn pendants and mounts in the second group of twelfth/early thirteenth-century horse furniture are clearly posed in the heraldic attitudes of their later, more heavily stylised, descendants (Figs 8 and 9, nos **20–9** and **30**). They rehearse such roles as *lion passant guardant* and *lion combatant*, and perhaps provide a transitional link between the naturalistic portrayal of animals in other Romanesque decorative arts (Foot 1984, 344 and 346) and those shown in early arms. The motif of pairs of animals, confronted or addorsed (*cf*. pendant no. **29** and Plate III), can be traced back at least as far as the Bayeux Tapestry, and was probably inspired both by eleventh-century English manuscript illustration and by woven silks imported from Persia and Byzantium (Hicks 1993, 252–3; Deér 1959, 92–4, and Heslop forthcoming). An example of one such silk which dates to the middle of the eleventh century, and

Plate IV *Two birds addorsed regardant* within running vine decoration, in the cloisters of Monreale Cathedral, Sicily (*Photo: SJA*)

which has paired birds, lions and griffins, was discovered in the tomb of Edward the Confessor (Granger-Taylor 1994, 151–3, fig.166). The widespread use of such decoration in architecture (ultimately derived in some part from classical antiquity, Deér 1959), and its absorption into armory, is nicely illustrated by the depiction of *two cranes confronted*, on one of a pair of shields supported by Romanesque lions in the castle of Roger I at Adrano, Sicily (Plate III)[7].

Another early twelfth-century architectural motif, a running vine deliniating a series of circular fields in which are placed either individual or paired beasts or monsters, is commonly found in Romanesque decoration (Plate IV). This motif may perhaps have had some influence on the development of the heraldic tressure, examples of which are present on twelfth and early thirteenth-century pendants and mounts nos **20, 22–3, 25** and **27–8** (Figs 8 and 9).

By the end of the twelfth century, the ability to depict arms on horse furniture in full was hampered only by the lack of readily available technology. However, it is a Limoges enamel in Le Mans which provides us with the first example of a coat of arms in colour, that shown on the funerary plaque of Geoffrey Plantagenet (1113–1151). It is clear that the evolution of the rules which govern the application of the colours of armory, and their nomenclature, is closely tied to the early development of enamelling (Taburet-Delahaye 1996c, 98–101 and Pastoureau 1996, 339–40).

Plate III *Two cranes confronted* on a shield supported by a Romanesque lion, at the castle of Roger I, Adrano, Sicily (*Photo: SJA*)

There was an increase in the use of heraldry in all aspects of the applied arts during the second half of the thirteenth century (Payne 1987, 56–7). In the case of armorial horse furniture, this trend was given an extra

impetus towards the end of the century by the spread of small-scale enamelling (and consequently the means by which to emblazon), a technological advance which could have been made in response to a demand for these objects during the military campaigns of Edward I (Campbell 1987, 164, and Griffiths 1995, 62). Mercury silvering also became widely available in the thirteenth century, a technique '...particularly suited to silvering items like heraldic pendants, which combined silvering with gilding and enamel work to give a polychrome effect' (La Niece 1993, 207). The degree of subtlety achieved by this combination of techniques can be seen on the pendant bearing the arms of Morley, where the gilt crown has been reserved in black enamel to separate it from the silver field (Frontispiece (b) and Fig.23 no. **225**).

Distribution

Only the most obvious of conclusions can be drawn from the distribution of finds of horse furniture within the county (Fig.1). This is due to a number of factors, not the least of these being the inherent portability of these classes of object, most losses occurring in transit (although there are occasional examples which must have been found close to home and repaired, *i.e.* Fig.11, no. **61** and Fig.13, no. **94**). An attempt to plot the distribution of those objects bearing the arms of Clare and of Warenne proved to be rather futile. The sample was too small to be meaningful, and produced a thin, widely dispersed, scatter. In the case of finds bearing the arms of minor, local, knights and lords, where the distribution may have proved to have been more significant, the sample is even smaller, comprising in most cases only a single example. Consequently, the map given here (Fig.1) reflects little more than the distribution of metal-detecting activity in Norfolk (*cf.* Gurney 1997). Little attempt has been made to study the archaeological or topographical context of each find. Many are isolated, others may lie on 'sites' of varying types or along the line of ancient roads and trackways.

In addition to these problems, difficulties with the precise dating of arms (even encountered with Rolls of Arms, see Denholm-Young 1965, 14), coupled with the great complexity of manorial structure in Norfolk at this time, precludes any but the most general of statements regarding the identification of the arms on the majority of pieces of horse furniture with the ownership of the land upon which they were found (see Blake 1952 and Campbell 1986 and 1993). One rare exception to this is a pendant (Fig.17, no. **158**) bearing the arms of the Bishopric of Norwich, found on the moated site of the Bishop's Palace, Hevingham. Walter de Suffield, Bishop of Norwich (1234–56) built his palace here in 1250 (Blomefield 1807, 375). The palace continued in the ownership of subsequent bishops of Norwich until *c.*1530 (SMR 7656). The complex manorial structure of Hevingham has been examined by Campbell (1986). This names the Bishop of Norwich as *capitas dominus ville*, alongside other lords with a share in the manorial free holdings, including the King, the Earl of Gloucester, the Priors of Gislingham and Broomholm, and John le Mareschal.

It is a rather predictable equation that the majority of losses of horse furniture would have been made close to home. This is born out by an analysis of the objects recovered which have identifiable arms. It has been possible to identify, with varying degrees of probability, 119 (49%) of a total of 241 of the arms illustrated here. The following estimates, although somewhat imprecise due to difficulties of definition, do at least provide some indication of general trends. Of these 119 identified arms, 19 (16%) represent the King (if allusive arms are included, this total is increased to 27, or 23%); 37 (31%) belong to great lords (with or without Norfolk lands) such as de Bohun[8], Earls of Hereford and Essex; and 35 (30%) local knights and lords, and religious establishments (for these purposes 'local' is considered to be Norfolk and neighbouring counties). The 16% of arms remaining are problematic.

Ownership

The previous paragraph leads naturally on to the slightly tricky question of the identification of those for whom these objects were intended. As noted earlier (page 28), pendants and mounts appear on the Second Great Seal of Richard I. A thirteenth-century aquamanile, thought to depict an equestrian English prince, has six shield-shaped pendants suspended from the breast-band of the horse, each of which displays the arms of England (Nelson 1916, 80–1 and plates 2a and 2b; this volume Plate V and Cover). A mid thirteenth-century English apocalypse portraying a king riding into battle shows at least three pendants worn in a similar manner (Plate VI). Examples such as these, although uncommon, indicate that the fashion for such furniture reached the highest levels of medieval society.

Griffiths has argued that armorial horse furniture would have been displayed (as marks of ownership) upon the mounts of the retainers of the knight or lord whose arms they carry (1986b, 1 and 1995, 62). Furniture worn on the horses of esquires or *armigeri*, who 'began by bearing quite literally the arms of their lords or knights they served' would obviously fall within this category (Denholm-Young 1969, 23). This reasoning must also apply to those examples bearing the arms of the King, in whose name sheriffs, bailiffs, stewards and suchlike acted, and would hold true for the larger lords and great seigneurial families, and religious houses and institutions.

However, the minor mostly local knights and gentry represented here, whose resources were limited, and who had few if any retainers, may have employed armorial horse furniture upon their own mounts. This was, perhaps in part, with the aim of 'keeping up with the Warennes' (an argument recently postulated for much moat building — another activity concerned with conspicuous display — during the thirteenth and early fourteenth centuries, by Rogerson 1993). The employment of base metal, and 'the generally poor quality of manufacture' (Griffiths 1986b, 1) of much armorial horse furniture, seems less significant as an argument against personal use when one sees a well-preserved example, with gilding and/or silvering, and polychrome enamelling intact (*cf.* Frontispiece, (a) and (b)), and considers the original overall effect that would have been achieved by many of these displayed together upon a harness. The cost of producing such an array must have been high, *cf.* late fourteenth-century prices for raw materials used in enamelling given in Campbell, M. (1987, 164–5). It may also be relevant to note here that a statute of 1363 restricted the wearing of precious metals and enamelling according to rank and wealth. Servants were forbidden to wear gold, silver or enamel (Campbell, M. 1991, 160–1).

Plate V A thirteenth-century aquamanile in the form of an equestrian English Prince
(*Soprintendenza per i Beni Artistici e Storici per le Provincie di Firenze-Pistoia-Prato*)

The idea of 'social closure' discussed recently by Hinton (1999) may be applicable here, where the public display and proclamation of symbols which are widely understood (at least on a basic level) is used to reinforce the sense of belonging to a restricted elite.

There appears to be some correlation between those whom Denholm-Young calls 'strenuous knights' (*ie* those who were active on campaigns against the Scots and the Welsh, Denholm-Young 1965, 8 and 1969, 15–6), and the commissioning of armorial horse furniture. Of the 119 (49%) identified arms, 42 (35%) would appear to belong to 'strenuous knights'. If those arms which represent the King (under whom these knights would have campaigned) are added, the total is increased to 61 (51%). When allusive arms are included, the total is further increased to 69 (59%). These figures are all the more striking when one considers that, according to a calculation based on the *Nomina Villarum* of 1316, of a population of between 2,500,000 and 3,000,000 there were 18,000 to 20,000 'Country Gentry', perhaps 2,000 (or *c.*10%) of whom could be classed as 'strenuous knights' (Denholm-Young 1969, 15–6).

Indentures of retainer hold some clues to the supply of horse furniture in general, although much work remains to be done on the publication of this class of documents (Jones and Walker 1994, 9–10). Unfortunately, any reference to specifically *armorial* horse furniture may be lost within the general term of 'livery'.

Decline

By the time the various statutes of limitation on the wearing of livery by retainers were introduced, the first of which appeared in 1399 (Jones and Walker 1994, 30–1), the fashion for armorial horse furniture appears to have been long in decline. Seals provide us with some evidence of the rise in popularity of the caparison (horse-cloth), which 'is shown intermittently from the mid-twelfth century, but appears invariably ... from the mid-thirteenth', and which may have, in part, supplanted the use of elaborate arrays of studs, mounts and pendants. However, these different classes of object could also be combined, as demonstrated by (although at much later date and higher social level) the second great seal of Henry VIII, of 1535–42, where a caparison is shown being worn in conjunction with pendants suspended from the reins of the horse (Harvey and McGuinness 1996, 47 and 31, no. 27). Furthermore the use of caparisons seems to have been restricted to military or pseudo-military occasions (parades and tournaments) and would not have replaced other styles of harness used when travelling or in other pastimes such as hunting.

Other changes in the structure of society may also have hastened the process of abandonment. During the course of the thirteenth century, the actual number of knights, a figure always open to some fluctuation, decreased noticeably (Coss 1991, 241–257). Lawyers, judges and 'self-made' men had helped to swell the ranks of the minor gentry from the early-fourteenth century (Denholm-Young 1969, 129–31). The creation of visible expressions of seigniorial power began to wane. There was, for example, a marked fall in the number of moats being built between 1325–c.1500 (Le Patourel and Roberts 1978, 51). The emphasis had moved from military prowess, to other, civilian, virtues (Jones and Walker 1994, 30–2).

Further Work

A spectacular discovery such as a set of leather harness with pendants and mounts *in situ*, or a workshop or a cache of moulds, would help to answer some of the questions raised in the writing of this book. However, many avenues remain open for investigation of existing material and sources.

A close examination of indentures, even bearing in mind the caveat noted above (p.31), could reveal information regarding questions of ownership. These forms of contract between lord and retainer list amongst other things, the issuing of livery robes and devices (Jones and Walker 1994, 12, 23–4, 30–3).

Not all of the conclusions drawn from this survey of Norfolk material will necessarily hold true for other areas. Objects of armorial horse furniture have come down to us mainly through accidental loss in transit, and so are rarely found in archaeological contexts. An understanding of their significance, therefore, is most likely to emerge from large-scale study of the objects themselves and their distribution across the wider feudal landscape. Complementary studies of this kind in other counties, and indeed, countries, such as an examination of museum collections and publication of archaeological reports, in Ireland[9], on the Continent of Europe[10], around the Mediterranean and in the Holy Land, should be undertaken. This would not only enlarge the sample, but more importantly, may even provide answers to some of the questions regarding the origins, the development and the spread of early armory.

Endnotes

1. Two of a projected four volumes have been published at time of writing (Chesshyre and Woodcock 1992 and Woodcock, Grant and Graham 1996).
2. For an expanded discussion of this idea see Ashley 2001.
3. Some of the above points relevant to pendant no. **29** have been discussed in a short note in *The Coat of Arms* (Ashley 1999b).
4. The precise meaning of the terms *miles* and *milites* remains debatable, see for example Bates 1982, 51–2 and 109–11, Crouch 1992, 120–2, Douglas 1969, 97, and Duby 1977, 76–9 and 158–70.
5. *cf.* The seal of Waleran II, Count of Meulan and Worcester, in Crouch 1992, fig.8. The other two carved faces of the piscina or basin (thought by Pevsner and Wilson 1998, 685, and Margeson 1994b, 67–8, to be a re-used capital) show: a mounted knight with checky surcoat spearing a dragon with a lance carrying a banner; and a dragon.
6. This is not the place to discuss the claims of Beryl Platts for continuity of use of armorial devices from their proposed genesis within the Carolingian empire (Platts 1980). However, material evidence for such claims seems at best inconclusive (see for example 'The Flemish Connection' a letter to the editor by Dr Bruce McAndrew (1993) in *The Double Tressure* 15, 43–6).
7. The arms depicted on these two shields (the second shield shows '*six and two half loaves*') are attributed to the family of Sclafani-Moncada (*Museo di Adrano, Etna Territorio Percorsi d'Arte,* 1999, 5; see also Palizzolo Gravina 1871–5, 265–8, 344–5 figs 48, no. 6 and 69, no. 6).
8. The family of de Bohun are well represented here with a total of twelve objects bearing their arms recorded in the Ordinary. They are descended from Humphrey de Bohun who held only one manor in all England in 1086, Tatterford in the hundred of Brothercross, Norfolk (Blake 1952, 250 and Brown 1984, entry no.40). Although later rising to prominence and vastly increasing their holdings elsewhere, the de Bohuns failed to add to their sole lordship in Norfolk (Blomefield 1805–10), and the relative frequency with which their arms occur here must be attributed to their national rather than local importance.
9. Four pendants of possible Irish provenance were published by E.C.R. Armstrong in 1912, and a short note on a suspension mount for a pendant (found at Doonmore castle mound) was published by Gordon Childe in 1938 (130).
10. A recently published catalogue of the 136 pieces of Spanish horse furniture held in the collection of the Museu Frederic Marès in Barcelona includes pendants from both Christian and Islamic Spain (Martín Ansón 1994) and Nick Griffiths is currently preparing for publication a group of continental horse furniture held in the collections of the British Museum which contains many objects of French, Italian and Spanish origin.

Plate VI Detail from an early thirteenth-century English Apocalypse
(*Master and Fellows of Trinity College, Cambridge*)

Appendix 1: Ordinary

The arms depicted are described as they appear, but if they can be identified with any of certainty the missing tinctures are added within square brackets. In the case of poor or wrong execution of arms the probable intention is noted where possible. The term 'Photo' is used for both photographs and polaroids. (*** indicates SMR number and/or parish name not yet available).

Bars
Two Bars Between
Or two bars Azure between three ?martlets Gules. Pendant, shield-shaped, with small circular attachment stud, shank on reverse. ?ROTHING, John de., from seal on document dated 13 Sept. 1359, Little Fransham, Norf. (untinctured) (Chesshyre and Woodcock 1992, 49). Slide NCM. SMR 18643 Bradwell.

Three Bars
Three bars (gilt ground stamped with pellets). Stud, square with lobed edges, shank on reverse. SMR 19631 Emneth.

64 *Argent three bars Azure.* Pendant, shield-shaped, remains of iron pin in suspension-loop. SMR 11585 Brampton.

117 *Argent three bars Gules.* Pendant, shield-shaped. Paired with identical pendant and a strap-fitting from same site (successive entries, drawings **118** and **119**). ?MULTON, probably a relative of Hubert de Multon of Isell, Cumb., and of Surlingham, Norf. (Brault 1997, 312–13). SMR 25690 Bylaugh.

118 *Argent three bars Gules.* Pendant, shield-shaped. Paired with identical pendant and a strap-fitting from same site (preceding and successive entries, drawings **117** and **119**). ?MULTON, (Brault 1997, 312–13). SMR 25690 Bylaugh.

119 *Argent three bars Gules.* Strap-fitting, rectangular, folded, with surviving rivet. Paired with two pendants from same site (preceeding entries, drawings **117** and **118**). ?MULTON, (Brault 1997, 312–13). SMR 25690 Bylaugh.

Gules three bars Or. Attachment plate, square, with four rivet-holes and H-shaped suspension-lug for pendant (now missing). ?REVIERS, Earl of Devon. Photo NCM. SMR 13009 Loddon.

Five Bars
?Or/Argent five bars Azure (on a shield, on a circular field Gules between three leaf-scrolls ?Or/Argent). Mount, circular with three rivet-holes. SMR 30866 North Creake.

Barry
Barry of Six
14 *Barry of six* (incised decoration with alternating stamped and plain bars). Pendant, triangular with slightly concave sides, lobed on both points at base, with suspension-loop springing from uppermost point, much gilding survives, once overall. SMR 34005 Martham.

Barry of ?six/eleven. Pendant, rectangular, gilded overall, with eleven engraved transverse lines. SMR 20273 Walpole St Peter.

164 *Barry of six ?Or/Argent and Azure.* Stud, lozengiform, shank on reverse. ?GREY, de, (if *Argent*), family held land in Norfolk. SMR 29713 Gayton.

?Barry/Paly
Barry/Paly of Six
165 *?Barry/paly of six [Or] and [Gules].* Stud, lozengiform, shank on reverse, enamelling and surface treatment of metal missing. ?Paired with strap-end (following entry, drawing **120**) found on the same site. SMR 28296 Suffield.

120 *?Barry/paly of six Or and Gules.* Strap-end, rectangular with single rivet surviving. ?Paired with lozengiform stud (preceeding entry, drawing **165**) found on the same site. SMR 28296 Suffield.

Beast
?Bull
30 *A winged ?bull couchant regardant to the sinister.* Pendant, trapezoidal, traces of gilding (probably once overall), suspension-loop missing. SMR 30636 Bradenham.

Dog
[?] A talbot statant on a mount ?Or/Argent. Mount, circular. Photo NCM. SMR *** ?Freethorpe.

Hart and in Base
84 *Or a hart trippant Argent attired Gules in base a ?hare Argent issuant from a mount Vert.* Pendant, shield-shaped, with suspension-stud, shank on reverse, attached by iron pin. SMR 32022 Ashill.

Lion Passant
[?] A lion passant ?Or/Argent (within a square field, from each side of which springs a fleur-de-lis ?Or/Argent into a foil [?]). Pendant, elaborate quatrefoil, suspension-loop broken, information taken from drawing in file, no note of metals or tinctures. ?Allusive for ENGLAND and FRANCE. Drawing NCM. SMR 8446 Horning.

Lion Passant Guardant
A lion ?passant guardant (within a circular gilt field with pecked decoration, fleur-de-lis in each corner of

border). Mount, square, with folded-over lug at base to take ?pendant. Two rivetted holes. SMR 1298 Holme-next-the-Sea.

24 *A lion passant guardant* (within a pelleted circle from which spring, inwardly and anti-clockwise, seven tendrils. Around the border is the following inscription: I E S V I [C] [H] R I S T V S : A M I (I am the friend of Christ)), gilded overall. Part of an elaborate set found on the same site (see drawings **19, 20, 21, 22** and **23**). Photo NCM. SMR 1058 Sporle with Palgrave.

A lion passant guardant ?Or/Argent. Pendant, square, very worn, suspension-loop missing. Photo NCM. SMR 30426 Mundham.

?Azure a lion passant guardant ?Or/Argent (on a square field from each side of which springs a fleur-de-lis ?Or/Argent into each foil Gules). Pendant, elaborate quatrefoil. ?Allusive for ENGLAND and FRANCE. Photo NCM. SMR 25811 Beeston Regis.

208 *[?] A lion passant guardant Argent* (on a square field from each side of which springs a fleur-de-lis Argent into each foil [?]). Pendant, elaborate quatrefoil, with traces of, now unidentifiable, decayed enamel. ?Allusive for ENGLAND and FRANCE. NCM. Frontispiece (a), this volume. SMR 33389 ?Norfolk.

[?] A lion passant guardant ?Or/Argent (on a square field from each side of which springs a fleur-de-lis ?Or/Argent into each foil [?]). Pendant, elaborate quatrefoil, very corroded with traces of unidentified enamel, suspension-loop broken. ?Allusive for ENGLAND and FRANCE. Drawing NCM. SMR 8446 Horning.

[?] A lion passant guardant ?Or/Argent (on a square field, from each side of which springs a fleur-de-lis into each foil). Pendant, elaborate quatrefoil. ?Allusive for ENGLAND and FRANCE. Photo NCM. SMR 24340 Tuttington.

Azure a lion passant guardant Or (within a square field from each side of which springs a fleur-de-lis Or into each foil Gules between four lobes azure). Pendant, elaborate quatrefoil with attachment stud, shank on reverse. ?Allusive for ENGLAND and FRANCE. Slide NCM. SMR *** Norfolk.

Azure a lion passant guardant ?Or/Argent (on a square field, from each side of which springs a fleur-de-lis ?Or/Argent into each foil ?Gules). Pendant, quatrefoil. ?Allusive for ENGLAND and FRANCE. Photo NCM. Paired with identical pendant from same site (following entry). SMR 24150 Binham.

Azure a lion passant guardant ?Or/Argent (on a square field, from each side of which springs a fleur-de-lis ?Or/Argent into each foil ?Gules). Pendant, quatrefoil. ?Allusive for ENGLAND and FRANCE. Photo NCM. Paired with identical pendant from same site (preceeding entry). SMR 24150 Binham.

213 *Azure a lion passant guardant ?Or/Argent* (on a square field, from each side of which springs a fleur-de-lis ?Or/Argent into each foil Gules between four lobes Gules). Pendant, elaborate quatrefoil. ?Allusive for ENGLAND and FRANCE. SMR *** Shouldham.

212 *Azure a lion passant ?guardant ?Or/Argent* (on a square field, from each side of which springs a fleur-de-lis ?Or/Argent into each foil Gules between four lobes Azure). Pendant, elaborate quatrefoil, suspension-loop broken. ?Allusive for ENGLAND and FRANCE. SMR 34050 Reepham.

211 *Gules a lion passant guardant Argent* (on a square field, from each side of which springs a fleur-de-lis Argent into each foil Azure between four lobes Gules). Pendant, elaborate quatrefoil, suspension-loop missing, traces of silvering survive. ?Allusive for ENGLAND and FRANCE. SMR 33438 Shouldham.

210 *Gules a lion passant guardant ?Or/Argent* (on a square field from each side of which springs a fleur-de-lis within a foil Azure). Pendant, elaborate quatrefoil. ?Allusive for ENGLAND and FRANCE. NCM. Frontispiece (a), this volume. SMR 33389 ?Norfolk.

209 *Gules a lion passant guardant ?Or/Argent* (on a square field from each side of which springs a fleur-de-lis ?Or/Argent into each foil Azure between four lobes Gules). Pendant, elaborate quatrefoil, very corroded, enamel largely decayed. ?Allusive for ENGLAND and FRANCE. SMR 3565 Congham.

171 *Gules a lion passant guardant Or* (on a square field within radiating linear decoration). Pendant, square, broken and bent. GUYENNE, Duke of. SMR 21515 Hales.

Lion Passant Guardant Crowned and Cinquefoils

173 *Azure a crowned lion passant guardant in dexter chief a cinquefoil in sinister chief and another in base Or* (on a shield set within gilt incised lozengiform decoration). Pendant, square. TRUBLEVILLE, of Normandy, and of the manor of Sherbourne in the twelfth century. Two other pendants bearing these arms have been found, one in Canterbury and one in Salisbury (London 1949b, 204–6, and Cherry 1991, 20–1 and fig.2, no.9). Photo NCM. SMR 24051 Quidenham.

Lion Passant Guardant Maculate

78 *Azure a ?lion passant guardant Or maculate Azure.* Pendant, shield-shaped, traces of iron around suspension-loop. SMR 25690 Bylaugh.

Lion Passant Guardant Between

88 *Or a lion passant guardant bendwise between two quatrefoils slipped [?].* Pendant, shield-shaped, suspension-loop missing. SMR 16297 Heacham.

Lion Passant Guardant Within

25 *A lion passant guardant to sinister within an annulet fleury.* Mount, square with rounded rectangular projections at top and foot, each pierced by a rivet-hole, rivet surviving in uppermost, surface

treament missing, probably once gilt overall. SMR 21431 Feltwell.

27 *A lion passant to sinister within an annulet fleury.* Pendant, square, small traces of silvering, probably once overall, iron-staining around suspension-loop. SMR 32896 Cawston.

23 *A lion passant guardant within an annulet fleury.* Suspension-mount, square with semi-circular lug, and broken suspension-loops, pierced by rivet-holes (one rivet surviving), gilded overall. Part of an elaborate set found on same site (see drawings **19**, **20**, **21**, **22** and **24**). Photo NCM. SMR 1058 Sporle with Palgrave.

22 *A lion passant guardant within an annulet fleury.* Suspension-mount, square, with semi-circular lug and suspension-loops, pierced by rivet-holes, gilded overall. A pendant, square, and bearing identical arms to those described above, is suspended from the mount by an iron pin. Part of an elaborate set found on the same site (see drawings **19**, **20**, **21**, **23** and **24**). Photo NCM. SMR 1058 Sporle with Palgrave.

20 *A lion passant guardant within an annulet fleury.* Suspension-mount, square, with two semi-circular lugs pierced by rivet-holes, and suspension-loops, gilded overall. A pendant, square, and bearing a *wyvern queue forchee passant to the sinister*, is suspended from the mount by a copper-alloy pin. Part of an elaborate set found on the same site (see drawings **19**, **21**, **22**, **23** and **24**). Photo NCM. SMR 1058 Sporle with Palgrave.

28 *A lion passant guardant to sinster within an annulet/tressure fleury.* Pendant, square, gilded overall. SMR 31295 Tattersett.

Gules a lion passant guardant Or within an orle of eight martlets Azure. Pendant, elaborate quatrefoil, suspension-loop missing. ?VALOINS (*martlets to sinister*, font, Barney Church, Norf.), ?Valoynes, Valomys (*martlets Argent*). Photo NCM. SMR 24150 Binham.

Lion Rampant

5 *A lion rampant.* Pendant, shield-shaped, slightly bent, gilding survives mostly in engraved decoration, once overall. SMR *** Aslacton)

A lion rampant (? between fleur-de-lis). Pendant, quatrefoil. SMR 24849 Thetford.

A lion rampant (on a shield-shaped field, between three ?birds). Pendant, quatrefoil, traces of enamelling. Photo NCM. SMR 25767 East Tuddenham.

A lion rampant. Pendant, shield-shaped, traces of red and other enamel. SMR 25068 West Winch.

116 *A lion rampant.* Suspension-plate, shield-shaped, shank on reverse, double suspension-loop formed from rectangular slotted strip springing from the foot of the shield and bent backwards and upwards into loops; remains of ?white metal coating (now discoloured) overall. SMR 30192 Roudham.

A lion rampant (within shield). Pendant, quatrefoil. SMR 9836 Caistor St Edmund.

?A lion rampant ?Or/Argent. ?Mount, fragment only, with feet of lion and one rivet-hole surviving. SMR 28284 Broome.

Azure a lion rampant Or. Pendant, shield-shaped. Photo FAD, film FUE 3–4. SMR 7625 Buxton with Lammas.

75 *Azure a lion rampant Argent.* Pendant, shield-shaped, white-metal on charge, unfortunately severely cleaned since discovery. ?COLVILLE, Colevile, Colvyle, Sir John, of Norf., or ?MOHAUT, Robert de, of Castle Rising, Norf. SMR 33055 Wramplingham.

205 *Azure a lion rampant ?Or/Argent* (in a square field from each side of which projects a fleur-de-lis /Or/Argent into each foil [?]). Pendant, quatrefoil, traces of iron pin in suspension-loop. ?Allusive for ENGLAND and FRANCE. SMR 29344 Morton-on-the-Hill.

Azure a lion rampant Or. Pendant, shield-shaped with attachment stud. ?BREWS, Thomas de, of Norfolk or ?NEVILLE. Photo NCM. SMR 13726 Great Dunham.

132 *?Or/Argent a lion rampant [?].* Stud, shield-shaped, shank on reverse, condition poor, enamel decayed and discoloured (now greenish). SMR 2373 Tattersett.

140 *?Or/Argent a lion rampant [?].* Stud, shield-shaped, enamel missing, remains of shank and lump of iron corrosion on reverse. SMR 1058 Sporle with Palgrave.

61 *?Or/Argent a lion rampant Azure.* Pendant, shield-shaped, bent, suspension-loop broken, secondary (replacement) hole in neck of original loop. SMR *** Clenchwarton.

141 *[?] A lion rampant ?Or/Argent.* Stud, shield-shaped, ?enamel missing, shank on reverse. SMR 4198 Little Dunham.

[?] A lion rampant ?Or/Argent. Stud, shield-shaped, shank on reverse, traces of unidentified enamel in field. SMR 21341 Walpole St Peter.

161 *Or a lion rampant Gules.* Pendant, lozengiform, remains of iron pin in suspension-loop. FELBRIGG, of Felbrigg, Norf. Photo NCM. SMR 32013 Quidenham.

146 *Or a lion rampant Gules.* Mount, shield-shaped, rivet-hole in base of shield. FELBRIGG, of Felbrigg, Norf. NCM 342.978. Margeson 1979, 227. SMR 13929 Fordham.

110 *Or a lion rampant [?].* Pendant, shield-shaped, small traces of decayed enamel and gilding survive, also

iron-staining in suspension-loop. SMR 34244 Ashwellthorpe.

Gules a lion rampant ?Azure. Pendant, shield-shaped. Photo FAD (not seen). SMR 25472 Beeston Regis.

203 *Gules a lion rampant Or* (on a lozenge, from each point of which springs a fleur-de-lis Or into each foil Azure). Pendant, quatrefoil. ?Allusive for ENGLAND and FRANCE. SMR 31840 North Walsham.

204 *Gules a lion rampant Or* (within a lozenge from each point of which springs a fleur-de-lis Or into each foil Azure). Pendant, quatrefoil, iron pin survives within suspension-loop. ?Allusive for ENGLAND and FRANCE. SMR 28230 Fincham.

190 *Gules a lion rampant ?Or/Argent* (on a shield between two wyverns and surmounted by two leaves conjoined). Stud, circular, convex, shank missing. Red enamel decayed and now mostly greenish in appearance. SMR 31168 West Acre.

Per pale Gules and Sable a lion rampant Or. ?Pendant, shield-shaped with 'crown' or 'W'-shaped ?remnant (bearing two incised lines forming an inverted V) of ?suspension-loop. ?BELER, (Kirby Beler Church, lion untinctured). Slide FAD. SMR 23703 Mautby.

Lion Rampant to Sinister
47 *[?] A lion rampant to sinister ?Or/Argent.* Pendant, shield-shaped, enamel missing. SMR 30286 Tattersett.

Lion Rampant Crowned
[?] A lion rampant crowned Or. Pendant, elaborate quatrefoil, enamel missing. Photo FAD (not seen). SMR 25473 Beeston Regis.

225 *Argent a lion rampant Sable crowned Or.* Pendant, engrailed octogon, with circular attachment stud, shank on reverse. MORLEY, William de, of Norf., s. and h. of Robert de Morley (d. after 1288), summoned against the Scots, 1299 and 1300–1, d. before 1302 leaving s. and h. Robert, d.1360 (Brault 1997, 304). (Gurney (Ed.) 1997, 395). Frontispiece (b), this volume. SMR 31161 Beeston Regis.

Azure a lion rampant crowned Or. Pendant, shield-shaped. ?PYKERYNG. Photo FAD, film FUE 3–4. SMR 7625 Buxton with Lammas.

Lion Rampant Crowned and Label
73 *[?] A lion rampant ?crowned ?Or/Argent a label of of three points Gules overall.* Pendant, shield-shaped, small fragment of enamelling survives. (CMAG no.152). NCM 222.76.94, (Rye 1909, no.982), Fitch Collection. Frontispiece (a), this volume. SMR 33388 Norfolk.

Lion Rampant Queue Forchee
71 *[?] A lion rampant queue forchee Argent.* Pendant, shield-shaped, remains of iron pin in suspension-loop, traces of decayed (now greenish) enamel on field. SMR 1058 Sporle with Palgrave.

[?] Lion rampant queue forchee ?Or/Argent. Stud, shield-shaped, enamel missing. Photo NCM. SMR 688 Norwich.

Gules a lion rampant queue forchee ?Or/Argent. ?Mount, shield-shaped. Slide NCM. SMR *** Norwich.

Lion Rampant Queue Forchee Crowned
74 *?Or semy of cross-crosslets a lion rampant queue forchee in saltire Gules crowned ?Or.* Pendant, shield-shaped, traces of gilding survive on shoulders of shield. ?BRAOSE, Brewes. SMR 34270 Kenninghall.

Lion Rampant Surmounted by
72 *Azure a lion rampant Argent surmounted by a bend Gules.* Pendant, shield-shaped, poor condition, traces of silvering survive. WEYLAND, Thomas de, of Brandeston and Whelnetham, Suff., disgraced, exiled in 1289, and then later pardoned and allowed to return to England, d.1298; or John de Weyland (Thomas's s. and h.), of Blaxhall and Ashbocking, Suff., held land in Suff. and Ireland, served against the Scots between 1297–1301, d.1312; or Roger de Weyland (unidentified, but probably related to the above), d.1298 (Brault 1997, 453). SMR 28131 West Rudham.

162 *[Or] a lion rampant queue forchee Vert surmounted by a bend compony [Argent] and Gules.* Pendant, lozengiform, suspension-loop missing. SUTTON (variation on known coats, combining a queue-forchee and a bend). SMR 25761 East Tuddenham.

Lion Rampant and Surmounted by Within
Or a lion rampant Azure surmounted by a bend within a bordure Gules. Pendant, square, suspension-loop missing. ?PERCY, Algernon, Bishop of Norwich., Percy, Thomas, Bishop of Norwich, 1356–69 (both without bend, ?for difference). Pers. comm. N.G. SMR 32265 'Thetford'.

Lion ?Sejant Erect
Gules a lion ?sejant erect ?Or/Argent. Pendant, circular, suspension-loop broken. Photo NCM. SMR 28493 Tuttington.

Between Two Lions Combatant
Between two lions combatant a staff fleury (on a pelleted field). Pendant, square, gilding overall. Photo NCM. SMR 29171 Besthorpe.

29 *Between two lions combatant a staff fleury* (on a pelleted field). Pendant, square, surface treatment now missing, probably once gilded overall. Photo NCM. SMR 32018 Kenninghall.

Two Lions Passant Guardant
172 *Gules two lions passant guardant ?Or/Argent.* Pendant, square. ?DELAMARE, Mare (if *Argent*), ?NORMANDY (if *Or*). Photo NCM. SMR 28230 Fincham.

Two Lions Rampant

Gules two lions rampant ?Or (on a shield set within a field Azure surrounded by area of cross-hatching). Attachment plate, ?circular with rivet-holes, gilt. SMR 28130 West Rudham.

Three Lions Passant Guardant

[Gules] three lions passant guardant [Or]. ?Mount, shield-shaped, foot missing. ENGLAND. SMR 30441 West Rudham.

50 *[Gules] three lions passant guardant [Or].* Pendant, shield-shaped, very worn, enamel missing. ENGLAND. (CMAG, no.122). NCM (?27.94), T. Bayfield Collection. SMR 33389 ?Norfolk.

[Gules] three lions passant guardant Or. Pendant, shield-shaped. ENGLAND. Pers. comm. N.G. SMR 32264 'Norfolk'.

[Gules] three lions passant guardant Or. Stud, shield-shaped. ENGLAND. SMR 1021 Oxborough.

207 *Gules three lions passant guardant Or* (on a shield between three fleur-de-lis Or on a field Azure). Pendant, quatrefoil. T.988.105. ENGLAND. Photo NCM. SMR 17271 Thetford.

127 *Gules three lions passant guardant [Or].* Stud, shield-shaped, shank on reverse. ENGLAND. SMR 34280 Burnham Norton.

51 *Gules three lions passant guardant [Or].* Pendant, shield-shaped, suspension-loop missing. ENGLAND. Photo NCM. SMR 30049 Fincham.

39 *Gules three lions passant guardant [Or].* Pendant, shield-shaped, remains of iron pin in suspension-loop. ENGLAND. SMR 30333 Fincham.

131 *Gules three lions passant guardant [Or].* Stud, shield-shaped, shank on reverse. ENGLAND. SMR 25252 Langham.

67 *Gules three lions passant guardant [Or].* Pendant, shield-shaped, suspension-loop bent. ENGLAND. SMR *** 'Filby'.

Gules three lions passant guardant Or. Pendant, shield-shaped, remains of iron pin in suspension-loop. ENGLAND. SMR 4697 Saham Toney/Little Cressingham.

40 *Gules three lions passant guardant Or.* Pendant, shield-shaped, suspension-loop broken. ENGLAND. SMR 4198 Little Dunham.

242 *Gules three lions passant guardant Or.* 'Banner', shield-shaped, with casting seam visible on edge of shield, attached by horizontal loop to vertical swivel rod. ENGLAND. (BFAC, 56, no.61), (CMAG, no.118). NCM. SMR 33389 ?Norfolk.

111 *Gules three lions passant guardant Or.* Pendant, shield-shaped. ENGLAND. (BFAC, 52, no.35), (CMAG, no.123). NCM 229.76.94, (Rye 1909 no.975). SMR 33388 Norfolk.

Gules three lions passant guardant Or. Pendant, shield-shaped. ENGLAND. SMR 4697 Saham Toney/Little Cressingham.

55 *Gules three lions passant guardant Or.* Pendant, shield-shaped. KLM 6.985. ENGLAND. Slide KLM. SMR 12539 Congham.

Gules three lions passant guardant Or. Pendant, shield-shaped, suspension-loop broken. ENGLAND. SMR 17940 Loddon.

Gules three lions passant guardant Or (on a shield between three ?trefoils). Pendant, lozengiform. ENGLAND. Photo NCM. SMR 28495 Wreningham.

56 *Gules three lions passant guardant Or.* Pendant, shield-shaped, bent, with iron pin and attached suspension-bar with two shanks on reverse. ENGLAND. SMR 31943 Tacolneston.

Gules three lions passant guardant Or. Pendant, ?shield-shaped, one edge damaged and suspension-loop broken. ENGLAND. SMR 28253 Great Walsingham.

180 *Gules three lions passant guardant Or* (on a shield within a circular field Azure, surrounded by gilt diaper-work). Suspension-plate, rectangular, with four rivet-holes and twin suspension-loops, broken. ENGLAND. SMR 31641 Cranworth.

38 *Gules three lions passant guardant Or.* Pendant, shield-shaped, attached to suspension-stud by iron pin, shank on reverse, gilding present on both shield and stud. ENGLAND. SMR 31879 Whissonsett.

215 *Gules three lions passant guardant Or* (set within Azure enamel in foils and lobes). Pendant, elaborate quatrefoil, very small traces of gilding, remains of iron pin in suspension-loop. ENGLAND. SMR 19139 Colney.

Three Lions Passant Guardant and Label

[Gules] three lions passant guardant [Or] a label of five points (label incised, ?secondary). ?Stud or mount, ovoid (?cut down). ENGLAND, with label as mark of cadency for eldest son of Edward I, II or III. Photo NCM. SMR 15284 Brettenham.

Gules three lions passant guardant Or a label of three points overall ('of France'). Pendant, shield-shaped. ENGLAND, with label 'of France'. LANCASTER, Thomas, Earl of, d.1322 or his s. and h. Henry, Duke of Lancaster (Fox-Davies 1950, 491, figs 702 and 704). Pers. comm. N.G. SMR 32264 'Norfolk'.

238 *Gules three lions passant guardant a label [?] overall.* Banner, rectangular, loop broken, enamel missing from label. ENGLAND, with label as mark of cadency for eldest son of Edward I, II or III. SMR 30049 Fincham.

128 *Gules three lions passant guardant Or a label Argent overall.* Stud, shield-shaped, shank on reverse. ENGLAND with label as mark of cadency for eldest son of Edward II or III. SMR 30362 Quidenham.

103 *Gules three lions passant guardant Or a label Azure overall.* Pendant, shield-shaped, suspension-loop missing. ENGLAND with label as a mark of cadency for the eldest son of either Edward I or II. SMR 32304 Ketteringham.

Three Lions Passant Guardant Within

186 *[Gules] three lions passant guardant Or within a bordure [Argent]* (on a shield surrounded by traces of originally ?red enamel). Pendant, circular, pale greenish decayed enamel and traces of gilding present. ?HOLLAND, Earl of Kent. SMR 33606 Beeston with Bittering.

Three Lions Passant Guardant Dimidiating

206 *Gules three lions passant guardant Or dimidiating Azure three ships hulls Or.* Pendant, quatrefoil, suspension-loop broken. WINCHELSEA, Cinque Port. Photo NCM. SMR 32012 Quidenham.

Three Lions Passant Guardant Impaling

57 *Gules three lions passant guardant impaling Or two bars and in chief three roundels Gules.* Pendant, shield-shaped, fragment of iron pin survives in suspension-loop. ENGLAND impaling ?WAKE, Baldwin, rebelled against the king and was captured at Northampton 1264, pardoned 1265, summoned against the Welsh 1277, d.1282 (Brault 1997, 440). SMR *** Shipdham.

Four Lions Rampant

106 *[Or] four lions rampant 1 and 4 Sable 2 and 3 Gules.* Pendant, shield-shaped. HAINALT, Philippa of (wife of Edward III). SMR 30954 North Lopham.

Six Lions Rampant

79 *Azure six lions rampant Argent.* Pendant, shield-shaped, remains of iron pin in suspension-loop. *cf. LMMC* 1954 plate xviii no.3, A8871 ('from London'). LEYBOURNE, de. SMR 30754 Congham.

Bend

[?] a bend ?Or/Argent. Pendant, shield-shaped, enamel missing, worn, suspension-loop broken. SMR 33825 Buxton with Lammas.

63 *Quarterly Or and Azure a bend Gules.* Pendant, shield-shaped, suspension-loop missing, very small traces of gilding survive. SMR 15060 Wickmere.

Bend and Label

A bend a label of five points overall. ?Mount, or ?pendant with suspension-loop missing, shield-shaped. Slide NCM. SMR 17045 Bunwell.

Bend Between

[?] A bend between six martlets ?Or/Argent. Strap distributor, shield-shaped with projecting bar at each corner, the top two terminating in circular attachment loops, the bottom loop missing, enamel missing. ?ECCLESHALL or ?SOMERY, Henry de, of Essex, living 1290 when serving as an attorney (Brault 1997, 394). Slide NCM. SMR 18120 Rollesby.

Bend Cotised

100 *?Or/Argent a bend ?cotised.* Pendant, shield-shaped, with two ?secondary holes in body of shield (for ?settings or ?attachment). *cf.* Goodall and Woodcock 1991, fig.12 no.2. SMR 14392 Congham.

Bend Cotised Between

[?] A bend ?cotised between two lions rampant ?Or/Argent. Stud, shield-shaped, shank on reverse. BOHUN, de, Earls of Hereford and Essex. SMR 25698 Postwick.

[?] A bend cotised between two lions rampant ?Or/Argent. Stud, shield-shaped, enamel missing. BOHUN, de, Earls of Hereford and Essex. Photo NCM. SMR 688 Norwich.

122 *Azure a bend [Argent] cotised between two lions rampant [Or].* Stud, shield-shaped, shank on reverse. BOHUN, de, Earls of Hereford and Essex. SMR 33080 Wymondham.

123 *Azure a bend [Argent] cotised between two lions rampant [Or].* Stud, shield-shaped, shank on reverse. BOHUN, de, Earls of Hereford and Essex. SMR 1659 Fring.

124 *Azure a bend [Argent] cotised between two lions rampant [Or].* Stud, shield-shaped, scar of missing shank on reverse, traces of gilding on side of shield. BOHUN, de, Earls of Hereford and Essex. SMR 33400 Broome/Ellingham.

81 *Azure a bend cotised between six lions rampant Or.* Pendant, shield-shaped, attached to suspension-bar by iron pin, twin shanks on reverse. BOHUN, de, Earls of Hereford and Essex. SMR 33424 Spixworth.

68 *Azure a bend [Argent] cotised between six lions rampant [Or].* Pendant, shield-shaped, broken at foot. Found in association with a suspension-bar, twin shanks on reverse. Fragments of iron pin survive in loops of both pendant and bar. BOHUN, de, Earls of Hereford and Essex. SMR 34367 Foxley.

Azure a bend Argent cotised between six lions rampant Or (on a shield). Suspension-mount. BOHUN, de, Earls of Hereford and Essex. Pers. comm. N.G. SMR 32264 'Norfolk'.

Azure a bend [Argent] cotised between six lions rampant [Or]. Pendant, shield-shaped. BOHUN, de, Earls of Hereford and Essex. Photo NCM. SMR 9950 Ashwellthorpe.

69 *Azure a bend Argent cotised between six lions rampant [Or].* Pendant, shield-shaped, iron-staining around suspension-loop. BOHUN, de, Earls of Hereford and Essex. SMR *** Thorpe Market.

80 *Azure a bend [Argent] cotised between six lions rampant [Or].* Pendant, shield-shaped, remains of iron pin in suspension-loop. BOHUN, de, Earls of Hereford and Essex. SMR *** Stody.

[Azure] a bend [Argent] cotised between six lions rampant [Or]. ?Mount, or ?pendant with suspension-loop missing, shield-shaped. BOHUN, de, Earls of Hereford and Essex. Photo NCM. SMR 13555 Bircham.

Bends
Two Bends
135 *?Or/Argent two bends [?] a label overall.* Stud, shield-shaped, shank on reverse, unfortunately severely cleaned since discovery, consequently all surface treatment missing. SMR 34522 Fakenham.

Five Bends
[Or] five bends Gules (on a shield flanked by three pairs of leaves). Mount, circular. TALBOT, Richard, of Eccleswall, Linton, Here., summoned to fight against the Scots 1297 and 1298, Sheriff of Glou. 1299–1301, d.1306 (Brault 1997, 409–10). Photo NCM. SMR 16870 Hethersett.

?Bendy
?Bendy. Stud, shield-shaped. SMR 8126 Horsham St Faith.

?Bezanty/Platty
121 *?Bezanty/platty.* Stud, shield-shaped, shank on reverse. SMR 30999 Mileham.

Bird
Or a bird [?]. Pendant, circular, enamel missing. Photo NCM. SMR 9310 Costessey.

188 *Or a bird Sable armed Gules.* Pendant, circular, damaged, some enamel missing and design obscured. SMR *** Spixworth.

Crane
166 *Or a crane passant Gules.* Stud, lozengiform, shank on reverse. ?CRANEMERE. SMR 31734 Foxley/Bawdeswell.

Eagle
An eagle displayed. Pendant, circular, gilt overall. Slide NCM. SMR *** Norwich.

237 *An ?eagle displayed* (on a shield, one of ?two fleur-de-lis springing from either side of the foot of the shield survives). ?Originally pendant, elaborate cruciform (*cf.* no.**236**), pierced at foot by rivet-hole, very worn and broken, traces of gilding, probably once overall. SMR 33122 Stratton Strawless.

An eagle displayed. Stud, shield-shaped, traces of red enamel survive. Photo FAD (not seen). SMR 25473 Beeston Regis.

219 *[?] An eagle displayed ?Or/Argent.* Pendant, elaborate quatrefoil, enamel missing, bent with suspension-loop missing. SMR 21302 West Acre.

[?] An eagle displayed ?Or/Argent. Pendant, circular, enamel unidentified. Photo NCM. SMR 688 Norwich.

Azure an eagle displayed Or (within border with diagonal rocker-arm decoration). Pendant, square. ?SCHOLDHAM, Sr de Wolverton., Schouldham or Schuldham (manor of Marham, Norf.). Photo NCM. SMR 30063 Deopham.

Gules an eagle displayed ?Or/Argent. Pendant, shield-shaped, suspension-loop worn. SMR 33822 Gresham.

145 *Gules an eagle displayed [?Or/Argent]* (one of at least ?three charges, ?possibly originally *Gules three eagles displayed [?Or/Argent]*). Mount, shield-shaped, broken and bent, lower half only surviving, notch in point at foot, probably for attachment. SMR *** Fincham.

143 *Or an eagle displayed Azure armed Gules.* Stud, shield-shaped, shank on reverse. SMR 30049 Fincham.

236 *Or an eagle displayed Sable* (on a shield set within a square zone of stamped annulets). Pendant, elaborate cruciform (projecting fleur-de-lis between arms of cross), circular hole in foot of cross with rivet for ?suspension. SMR 28569 Sporle with Palgrave.

?Or/Argent an eagle displayed ?Sable armed Gules. Pendant, shield-shaped, suspension-loop missing. Slide NCM. SMR 19114 Wereham.

Double-Headed Eagle
A double-headed eagle displayed. Pendant, badly bent. SMR 30590 Blo Norton.

A double-headed eagle displayed Or. Stud, shank on reverse. SMR 30018 Upper Sheringham.

Eagle Charged with an Escutcheon
An eagle displayed Gules charged with an escutcheon bearing three lions rampant (the field of the escutcheon is white, probably decayed, enamel). Pendant, lozengiform. Pers. comm. N.G. SMR 32264 'Norfolk'.

Eagle and Chief
Or a double-headed eagle displayed a chief Gules. Pendant, lozengiform, suspension-loop broken. ?BLUET (without chief, ?for difference). Photo NCM. SMR 24150 Binham.

Eagle and Over All
130 *[Or] an eagle displayed Sable surmounted by a bend compony [Argent] and [Gules].* Stud, shield-shaped, shank on reverse, small traces of black enamel survive. LINDSAY, ?Philip de, of Covington, Dumfries (Scotland), Marston and Carleton, Lincs., and of Northumb. and Cumb., summoned to serve against the

Scots 1300, 1301, and 1314, living in 1316 when he joined the Scots rebels and forfeited all his lands (Brault 1997, 259). SMR *** Roudham.

Owl
[?] An owl passant guardant ?Or/Argent (on a shield between engraved foliate decoration). Stud, circular, shank missing. Photo NCM. SMR 24884 Tuttington.

187 *Or an owl passant guardant close Argent*. Pendant, circular. Shown in *The Searcher*, Aug. 1998, 28. *cf. LMMC* 1954 plate xxi, no.4, A 3932 ('from London Wall'). SMR 33294 Costessey.

?Or/Argent an ?owl [?]. Stud, shield-shaped, shank on reverse. Photo NCM. SMR 25594 East Dereham.

Peacock
70 *Or a peacock close crested [?and armed] [Gules] passant*. Pendant, shield-shaped, bent, traces of decayed, probably once red (now pale green), enamel in crest of the bird. SMR 35103 Sculthorpe.

87 *?Or/Argent a peacock in his pride Gules and [?]* (for reverse of pendant see under 'Label'). Pendant, shield-shaped, bent, traces of unidentifed enamel in 'eyes' of feathers, suspension-loop broken, decorated on, and ?presumably therefore designed to be seen from, both sides. ?SUMERI (*a peacock in his pride*, untinctured). SMR 29896 Attleborough.

?Or/Argent a peacock in its pride Vert winged Gules maculate Vert beaked and legged Azure. Stud, circular, shank on reverse. Photo NCM. SMR *** ?Norfolk.

Or a ?peacock Gules head neck and coxcomb Azure. Pendant, lozengiform with vertical rectangular suspension-bar. ?SUMERI. SMR 29196 Croxton.

Pelican
241 *[?] A pelican in her piety Or* (repeated on reverse). 'Banner', shield-shaped, with horizontal loop, very decayed enamel present, possibly once *Gules*, now pale green in appearance. SMR 32764 Roydon.

Raven
Or a ?raven close [?] (repeated on reverse). ?Headstall-mount, shield-shaped, foot flaring into a tapering octofoil from the broad base of which springs an integral hook, possibly once part of an elaborate set. *Treasure Hunting*, Dec. 1997, 71. SMR 34248 'Norfolk'.

Swan Between
A swan between three trefoils slipped, and, on the reverse, *Lozengy Gules and ?Or/Argent a label of three points overall* (incised, secondary). Pendant, shield-shaped. Pers. comm. N.G. SMR 32264 'Norfolk'.

Birds
Two Birds Addorsed
Two birds addorsed. Pendant, with central rivet, within quatrefoil frame, gilding overall. NCM 983.287. SMR 16260 Horsham St Faith.

Two birds addorsed. Pendant, rectangular, gilded, with engraved decoration, suspension-loop missing. Photo NCM (not seen). SMR 30611 West Rudham.

Six Eagles
Gules six eagles displayed Or. Pendant, shield-shaped. ?BROCBURN or ?LIMESY, Ralph de, d. before 1325. Photo NCM. SMR 25523 Weeting with Broomhill.

Castle
245 *Gules a triple-towered castle Or* (on a rectangular field, between engraved lozengiform decoration). Hooked mount, rectangular, pierced by three rivet-holes. ?CASTILLE. Photo FAD. SMR 31879 Whissonsett.

179 *Gules a triple-towered castle [Or]*. (For description see no.**179**, under **Three Fleur-de-lis**). SMR 3036 Bradenham.

Checky
1 *Checky*. ?Mount, shield-shaped ('Kite-shaped shield'), with incised linear decoration, no trace of surface treatment of metal, probably once gilded overall, broken at the foot and bent in half lengthways. ?WARENNE, Earls of Surrey. Excavated find, site 845N, Greyfriars, Norwich, small find no.1452, context 30,900 (?twelfth-century quarry pit). SMR 845 Norwich.

Checky Or and Azure. Pendant, shield-shaped. WARENNE, Earls of Surrey. Pers. comm. N.G. SMR 32264 'Norfolk'.

92 *Checky Or and Azure*. Pendant, shield-shaped, remains of iron pin in suspension-loop. WARENNE, Earls of Surrey. Photo NCM. SMR 19545 Kenninghall.

Checky Or and Azure. Mount, shield-shaped. WARENNE, Earls of Surrey. Photo FAD, film CXJ. SMR 22211 Congham.

142 *Checky ?Or/Argent and Azure*. Stud, shield-shaped, remnant of broken shank on reverse. ?WARENNE, Earls of Surrey. SMR 25579 Fincham.

Checky and Label
125 *Checky Or and Gules a label overall ?Argent* (enamel in label decayed and ?possibly discoloured). Shield-shaped stud, shank on reverse with circular rove, broken. ?MULTON, Hubert de, of Isell, Cumb., and of Surlingham, Norf., summoned against the Scots 1296, d.1300 (Brault 1997, 312). SMR *** Weybourne.

Chevron

65 *Argent a chevron [?]*. Pendant, shield-shaped, small traces of silvering, and enamel, decayed and discoloured (now greenish). SMR 31235 Emneth.

Chevron Between

239 *Or a chevron between three lions rampant Gules* (lions to sinister on reverse). Banner, rectangular. ?HALES, Mill Steph., Holt, Norf., (brass of 1474, Warham All Saints Ch.) or ?REYMES, John de, senior, Norf., (Seals 1359 and 1396), both untinctured (Rye 1913, 729). NCM 346.978. (Margeson 1979, 228). Frontispiece (a), this volume. SMR 13852 Horsford.

195 *[?] A chevron ?Or/Argent between three roses ?Or/Argent* (on a shield between leaves picked out in ?inlaid metal). ?Mount, circular, enamel missing, pierced by ?rivet-hole above shield. (CMAG, no.165). NCM 236.76.94, (Rye 1909, no. 988). SMR 33389 ?Norfolk.

On a Chevron

134 *Ermine on a chevron Gules three mullets Or*. Stud, shield-shaped, shank on reverse, condition poor. HATTON or Hotton. SMR 33114 Sprowston.

Chevrons

Two Chevrons Between

Two chevrons between ?eight sexfoils (?2,4,?2). Pendant, circular, gilding present (probably once overall), very worn. Photo NCM. SMR 21481 Honing.

Three Chevrons

Three chevrons (on shield). Pendant, quatrefoil, suspension-loop broken, rivet-hole in foil at base of shield. SMR 19047 Walsoken.

Three chevrons (on a shield, three leaves springing from each corner of shield into lobes of trefoil). ?Mount or stud, trefoil. ?CLARE, de, Earls of Gloucester and Hereford. Photo FAD, CUH 5–8. SMR 21303 West Acre.

147 *Three chevrons*. Mount, shield-shaped with engraved decoration, surface treatment of metal missing, three rivets and a slight flange on reverse. ?CLARE, de, Earls of Gloucester and Hereford. SMR 31295 Tattersett.

[?] Three chevrons ?Or/Argent. ?Pendant or stud with hook, circular, bottom edge ?broken and notched. ?CLARE, de, Earls of Gloucester and Hereford. Slide NCM. SMR *** ?Norfolk.

[?] Three chevrons ?Or/Argent (on a shield). Pendant, quatrefoil, with pierced hole at base of shield (secondary), and possible suspension-hole at foot of broken foil in base. White (probably decayed) enamel present in field of shield. ?CLARE, de, Earls of Gloucester and Hereford. Photo NCM. SMR 15793 Horsham St Faith.

185 *Azure three chevrons [Or]* (on a shield flanked by decayed and now unidentifiable enamel). Pendant, circular, suspension-loop formed from integral backwards-bent strip springing from top of pendant, circular ?partially plugged or unfinished hole in base of shield. ASHPOLE, Sir John of Essex, Aspale, Aspal. SMR 21515 Hales.

Or three chevrons Gules (on shield between three cinquefoils). Pendant, elaborate quatrefoil. CLARE, de, Earls of Gloucester and Hereford. Slide FAD. SMR 13603 Postwick.

48 *[Or] three chevrons Gules*. Pendant, shield-shaped, bent. ?CLARE, de, Earls of Gloucester and Hereford. SMR 33036 Brinton.

59 *[Or] three chevrons Gules*. Pendant, shield-shaped. ?CLARE, de, Earls of Gloucester and Hereford. SMR 31559 Sporle with Palgrave.

Three Chevrons Within

[Argent] three chevrons Gules within a bordure engrailed Sable. Pendant, shield-shaped. WATERVILLE, Robert de, of Essex. Slide NCM. SMR 16555 Hemsby.

Chief

Chief Indented

133 *[Argent] a chief indented Gules*. Stud, shield-shaped, shank on reverse with attached rove. ?HENGRAVE, Edmund de, of Hengrave, Suffolk, Sheriff of Norf. and Suff., and keeper of Norwich Castle 1320–21, d.1334 (Brault 1997, 224). SMR 30954 North Lopham.

156 *?Or/Argent a chief indented Azure*. Pendant, lozengiform, bent, very small fragment of enamel survives. SMR 33764 Booton.

104 *[Argent] a chief indented Gules*. Pendant, shield-shaped. ?HENGRAVE, Edmund de, of Hengrave, Suffolk, Sheriff of Norf. and Suff., and keeper of Norwich Castle 1320–21, d.1334 (Brault 1997, 224). Tinctures and family previously misidentified as those of Harsick (*Or a chief indented Sable*) (BFAC, 57 no.71), (CMAG no.156). NCM 224.76.94, (Rye 1909 no.980), Fitch Collection. Frontispiece (a), this volume. SMR 33388 Norfolk.

On a Chief

139 *Or on a chief Azure two mullets Or*. Stud, shield-shaped, long spike on reverse. SMR 30821 West Acre.

54 *Or on a chief Gules two mullets of six points Or pierced [?]*. Pendant, shield-shaped, traces of decayed enamel (now pale green) survive within pierced mullets, also iron within suspension-loop. Photo NCM. SMR 25579 Fincham.

136 *Or on a chief Gules two mullets of six points Or pierced Gules*. Stud, shield-shaped, shank on reverse, set off-centre. SMR 30611 West Rudham.

?Combs
Three ?Combs
76 *Gules three ?combs in pale ?Or/Argent*. Pendant, shield-shaped, with suspension-stud, shank on reverse, attached by iron pin. Traces of red enamel, now mostly decayed and mutated to pale green. SMR 31294 Tattersett.

Cross
A cross. Pendant, shield-shaped, traces of gilding. Photo NCM. SMR 23295 Belton.

36 *Argent a cross [?Gules]* (on a shield within a circular inscription, now illegible). Pendant, circular, suspension-hole above shield, traces of silvering/tinning on shield and inscription, enamel missing from within cross. ?ST GEORGE. SMR 32939 Sporle with Palgrave.

113 *Argent a cross Gules*. Pendant, shield-shaped. ST GEORGE. SMR 31641 Cranworth.

Azure billetty a cross Or. Pendant, shield-shaped, suspension-loop missing. Photo NCM. SMR 30205 Ashwellthorpe.

37 *Gules a cross Or* (on a circular field on square terminals to three, originally four, radiating arms). Pendant, very elaborate, square stepped hollow boss, bent and broken, with square sectioned suspension-arm with broken suspension-loop. From each corner of the boss projects, saltire-wise, an arm ending in a flat, square, terminal, each of which is decorated with a gilt cross set on a red enamelled circular field within pelleted gilt decoration. Placed within the open top of the square boss, and crimped into four slots, one on each side, is a flat square with three (originally four) projecting arms, forming a cross. Each of these arms ends in an animal-head terminal. The central square has a red enamelled roundel with gilt central boss, set within pelleted gilt decoration. Photo NCM. SMR 23633 Wormegay.

115 *Or a cross Azure* (on a shield between five roundels). Pendant, rectangular, with three lobes projecting from either side and base, very small traces of gilding survive on shield. ?BOUN, John de. Photo NCM. SMR 34266 Kelling.

35 *Or a cross Gules* (on a shield, within a circular, garbled, inscription which reads: E ?D U[or W] : A I D A R D ?A ?I ?G A X[or H] D V A +). Pendant, circular, suspension-loop broken. ?BIGOD, Roger le, Earl of Norf. and Marshall of England, d. without issue 1306 (Brault 1997, 53–4) SMR 31763 Bawdeswell.

41 *?Or/Argent a cross Gules*. Pendant, shield-shaped, worn, suspension-loop broken. ?ST GEORGE. SMR 32032 Ormesby St Margaret.

33 *Quarterly Gules and Azure a cross Or overall* (on a shield, between small stamped annulets and a fleur-de-lis at each corner). Pendant, square, remains of iron pin in suspension-loop. SMR 30286 Tattersett.

Cross Engrailed
3 *A ?cross engrailed* . Pendant, shield-shaped ('almond-shaped' shield), traces of gilding on cross, possibly once all over, very worn, bent and broken (foot missing). SMR 32304 Ketteringham.

102 *[?] A cross engrailed Or*. Pendant, shield-shaped, enamel missing, bent. SMR *** Fring.

189 *[?] A cross engrailed Or*. Stud, circular, shank on reverse, decayed (greenish-white) enamel present. Excavated find from site 777N, Castle Mall, Norwich, small find no. 7042, context 50284. SMR 777 Norwich.

222 *[?] A cross engrailed ?Or/Argent*. Stud, elaborate quatrefoil, shank on reverse, decayed (greenish) enamel present. SMR *** Bacton.

220 *[?] A cross engrailed Or*. Pendant, elaborate quatrefoil, small traces of decayed and discoloured enamel and gilding, pendant unfortunately severely cleaned since discovery. SMR 34269 Happisburgh.

Azure a cross engrailed ?Or/Argent. Pendant, engrailed octagon. Pers. comm. N.G. SMR 32264 'Norfolk'.

Azure a cross engrailed Or (?on a shield, a beast within the foil above). Pendant, elaborate quatrefoil. Pers. comm. N.G (it is possible that this is the same pendant as that bearing a different, and possibly erroneous, description listed below, SMR 23329). SMR 32266 'Walsingham'.

?Or/Argent a cross engrailed Sable. Pendant. ?MOONE. SMR 8446 Horning.

95 *Sable a cross engrailed ?Or/Argent*. Pendant, shield-shaped, with suspension-stud with shank on reverse, attached by iron pin, traces of gilding on suspension-stud but surface of shield has been severely cleaned since discovery, thereby removing all trace of original treatment of metal. SMR 32975 Carbrooke.

?Sable a cross engrailed ?Or. Pendant, elaborate quatrefoil. ?UFFORD, Robert de, of Suff. Slide FAD (see above, SMR 32266). SMR 23329 Little Walsingham.

Cross Fleury
A cross ?fleury ?Or/Argent (on a circular field). Pendant, square, suspension-loop missing. SMR 30429 Salle.

[?] A Cross fleury ?Or/Argent (on a shield within a circular field, chequer pattern in corners of border). Pendant, square. Photo NCM. SMR 1121 North Elmham.

148 *[?] A cross fleury ?Or/Argent*. Mount, shield-shaped, surface treatment and ?enamel missing, indentations on top, base and sides of shield caused by attachment. ?Bishop ALNWICK. (BFAC, 55 no.56), (CMAG,

no.153). NCM 228,76.94, (Rye 1909 no.978). Frontispiece (a), this volume. SMR 33388 Norfolk.

Cross Indented
A cross indented. Pendant, quatrefoil. SMR 15611 Bacton.

42 *[?] A cross indented Or.* Pendant, shield-shaped, traces of decayed enamel (now pale green), and iron pin in suspension-loop. Photo NCM. SMR 30049 Fincham.

Cross Patee
A cross patee (on cross-hatched field). ?Pendant, circular, broken, ?suspension-loop missing, incised decoration, probably originally ?gilded overall. Found on excavations of a deserted medieval village at Thuxton, (Butler 1989, 36, fig.25, no.15). SMR 8842 Thuxton.

Cross Patonce
112 *Gules a cross patonce Ermine.* Pendant, shield-shaped, suspension-loop broken. SMR 31767 East Harling.

Cross Potent
122 *A Cross potent.* Pendant, lozengiform, incised decoration. Redrawn from original in SMR. SMR 4188 Great Dunham.

Cross Recercelee
62 *Per pale ?Or and [?Vert] a cross recercelee Gules.* Pendant, shield-shaped, with suspension-spike attached by iron pin, found on beach consequently much of surface corroded by action of sea, traces of gilding on loop of suspension-spike. INGHAM, ?Oliver de, of Ingham, Norf., summoned against the Scots 1311, 1314, 1317 and 1323, and as a baron in 1328, d.1344 (Rye 1913, 390). SMR 35002 Sea Palling.

Azure a cross recercelee Or. Pendant, circular. SMR 17342 Fulmodeston.

Cross of Toulouse
183 *[?] A cross of Toulouse ?Or/Argent voided.* Pendant, circular, traces decayed enamel in field, and of inlaid ?silver or niello decoration around field. KLM 45.972. SMR 32086 ?Swaffham.

175 *Azure a cross of Toulouse Or voided Azure* (circular field, gilding survives mainly within incised lozengiform decoration in border). Mount, square, with four rivets. Paired with another found nearby (following entry, drawing **176**). Photo NCM. SMR 4360 Fincham.

176 *Azure a cross of Toulouse Or voided Azure* (circular field, gilding survives mainly within incised lozengiform decoration in border). Mount, square. Paired with another found nearby (preceeding entry, drawing **175**). Photo NCM. SMR 4360 Fincham.

184 *Azure a cross of Toulouse Or voided Gules.* Pendant, circular. Similar to, and possibly paired with, two mounts found nearby (preceeding entries, drawings **175** and **176**). Photo NCM. SMR 28230 Fincham.

177 *Azure a cross of Toulouse Or voided Gules* (on a circular field). Mount, square, pierced rectangular projecting lug at top, ?another missing from foot. SMR 30343 Banham.

174 *Azure a cross of Toulouse Or voided Gules* (on a circular field). Pendant, square, rivet-hole in base, gilding survives mainly within incised lozengiform decoration surrounding circular field. SMR 33250 Wiveton.

Cross Between
Fig.3 *A cross between four estoiles* (traces of unidentified decoration at foot of cross). Lead ?trial-piece for pendant, shield-shaped, cast, with pierced suspension-loop, slightly damaged. Very rare, probable evidence for local manufacture of copper-alloy pendants. SMR 34131 Oxborough.

[?] A cross between four ?leaves ?Or/Argent. Stud, circular, with shank. Rocker-arm ornament around border, punched dots on cross and leaves. Photo NCM. SMR 25523 Weeting with Broomhill.

218 *Azure a cross patonce between five martlets [Or].* Pendant, quatrefoil. ST EDWARD. SMR 33016 Fincham.

217 *Azure a cross patonce between five martlets to sinister Or.* Pendant, elaborate quatrefoil. ST EDWARD (martlets erroneously shown to sinister). SMR 31861 Little Barningham.

Cross and Canton
137 *?Or/Argent a cross Gules a canton Ermine.* Stud, shield-shaped, shank on reverse with attached rove and fragment of leather. Paired with identical stud (following entry, drawing **138**) found on the same site. SMR 25991 Suffield.

138 *?Or/Argent a cross [Gules] a canton Ermine.* Stud, shield-shaped, shank on reverse with attached rove and fragment of leather. Paired with identical stud (preceeding entry, drawing **137**) found on the same site. SMR 25991 Suffield.

On a Cross
44 *[Or] on a cross moline Gules five lozenges Vair.* ?Pendant or stud, shield-shaped (if pendant then suspension-loop missing). Redrawn from original in secondary file. FREVILLE, Baldwin de, held Wellingham, Norf. *c.*1286, d.1289 (Brault 1997, 185). SMR 16848 Bixley.

101 *Or on a cross [?] five mullets of six points Or pierced [?].* Pendant, shield-shaped, traces of decayed unidentified enamel and iron pin in suspension-loop. ?GRINDALE, Robert de, Grymeles or Grymes (if *Gules*). 29265 North Creake.

[Sable] on a cross [Or] five pierced cinquefoils [Sable]. Pendant, elaborate quatrefoil,

suspension-stud, shank on reverse, attached by iron pin. Bishopric of ST DAVIDS. (Margeson 1993, 223–4, fig. 171 no.1811). SMR 281 Norwich.

Cross and Chief

114 *Or a cross Azure on a chief five bezants.* Pendant, elaborate shield-shaped, suspension-stud, shank on reverse, attached by iron pin. SMR 31934 Aylmerton.

Cross Impaling

Or a cross engrailed [?] impailing Azure three bishops mitres Or. Pendant, lozengiform. [?] impaling the Bishopric of NORWICH. SMR 31380 Felthorpe.

157 *[?] A cross engrailed ?Or/Argent impaling Azure three bishops mitres [Or].* Pendant, lozengiform. [?] impaling the Bishopric of NORWICH. SMR 20864 Horning.

Cross Within

200 *Azure a cross patonce within a bordure sable.* Pendant, quatrefoil, suspension-loop broken, black enamel also present on sides and reverse. SMR 34372 Postwick.

Crown

A crown [?enfiled by] two arrows in saltire. Pendant, trefoil, enamel missing. ?SOUTHWOLD or ?BURY ST EDMUNDS. Pers. comm. N.G. SMR 32264 'Norfolk'.

Crowns

Three Crowns

66 *[?] Three crowns Or (2:1).* Pendant, shield-shaped, worn, enamel missing, small fragment of gilding survives. ?Bishopric of ELY, or ?ST EDMUND. SMR 33767 Aylsham.

198 *Gules three crowns [Or].* Pendant, trefoil, suspension-loop broken. Bishopric of ELY. SMR 33628 Wereham.

196 *Gules three crowns Or* (on a shield surrounded by three dragons Azure). Mount, circular, indentations on edge resulting from attachment to ?leather or ?wood. Bishopric of ELY. SMR 34512 Holme Hale.

197 *Gules three crowns Or.* Pendant, trefoil, remains of iron pin in suspension-loop. Bishopric of ELY. SMR 32939 Sporle with Palgrave.

Gules three crowns in pale Or. Pendant, lozengiform. Bishopric of ELY. Pers. comm. N.G. SMR 32266 'Walsingham'.

Gules three crowns ?Or/Argent. Pendant, trefoil. ?Bishopric of ELY (if Or). SMR 20173 Oxborough.

Escarbuncle

Azure an ?escarbuncle (or ?six cinquefoils, stems conjoined in fess point) Or/Argent. Pendant, elaborate, six-sided between floriate projections. Photo NCM. SMR 21784 Horsham St Faith.

233 *Azure an ?escarbuncle of six arms fleury Or/Argent.* Pendant, fleury arm in base bent and broken. SMR 4185 Sporle with Palgrave.

235 *Azure an ?escarbuncle of six arms five with cinquefoil terminals that in base fleury ?Or/Argent* (on a circular field). Pendant, escarbuncle of six arms, each bearing a blue enamelled roundel, and ending in a lozengiform terminal with fleury projections and containing a quatrefoil azure. NCM 390.76.94, (Rye 1909 no.615), Fitch Collection. *Archaeol. J.* 12, 89. SMR 33392 Southacre.

Escarbuncle Impaling

Gules an escarbuncle pommetty and cojoined [Or] impaling [Azure] a bend [Argent] cotised [Or] (on a shield from either side of which springs a fleur-de-lis). Pendant, rectangular, suspension-loop missing, enamel missing. NAVARRE and CHAMPAGNE, Blanche d'Artois, Countess of Champagne, wid. of Henry III of Navarre m. Edmund Crouchback, Earl of Lancaster, subsequently Count of Champagne 1275–1284 (Brault 1997, 316–7). Photo NCM. SMR 29875 Deopham.

Escutcheon

31 *An escutcheon.* Pendant, square, gilded, suspension-loop broken. SMR 30636 Bradenham.

An escutcheon Gules. Pendant, ?saltire-shaped, badly corroded. SMR 20408 Horning.

Escutcheon Within

108 *?Or/Argent an escutcheon within an orle of eight martlets Gules.* Pendant, shield-shaped. ?VANE, Vanly, Vaulx or Vaux, of Norf. (if *Argent*). SMR 31326 Quidenham.

Estoile

Estoile of Eight Points

168 *Azure an estoile of eight points Or* (gilding survives mostly within incised decoration on estoile). Mount, lozengifom, pierced in centre by rivet-hole. ?OGAND. SMR 32607 Tattersett.

169 *Azure an estoile of eight points Or.* Mount, lozengiform, damaged, pierced in the centre by rivet-hole. ?OGAND. SMR 24776 Fransham.

Fermaux

Three Fermaux Surmounted by

89 *[?] Three fermaux ?Or/Argent surmounted by a bend ?Or/Argent.* Pendant, shield-shaped, enamel missing, traces of iron pin in broken suspension-loop. ?ROSSELYNE, Norfolk, Sire William Rosselyn, (both without bend, ?for difference). NCM 76.941.SMR 33389 ?Norfolk.

Fess

93 *A ?fess.* Pendant, shield-shaped, gilt decoration (possibly once overall). SMR 1555 Ingoldisthorpe.

129 *Checky [Or] and Azure a fess Gules.* Stud, shield-shaped, shank on reverse. CLIFFORD, ?Robert de, 'one of the most active men of his time' (Brault 1997, 109), summoned against the Scots 1299–1314, Keeper of Caerlaverock castle after the siege 1300, captain of the King's forces in Scotland 1308, slain at Bannockburn 1314. Sealed with these arms 1301; or Clifford, Roger de, senior, godfather to Robert (see above), fought for the King at Lewes (taken prisoner) 1264, and at Evesham 1265. Justice in eyre, Rut., Surr., Hants., Dors., Som., and Glou., 1269. Summoned against the Welsh 1277, d.1286. Sealed with these arms late *temp.* Henry III. (Brault 1997, 109). SMR 34268 North Walsham.

58 *Checky Or and Azure a fess Gules.* Pendant, shield-shaped, remains of iron pin in suspension-loop. CLIFFORD, (Brault 1997, 109). SMR 33384 Little Barningham.

144 *Checky [Or] and Gules a fess Ermine.* Stud, shield-shaped, bifurcated shank on reverse, broken, small traces of red enamel in *checky* field although mostly decayed and discoloured. FITZJOHN, Robert, Sheriff of Norfolk and Constable of Norwich Castle 1274–75, Steward of the King's household 1278–86, d.*c.*1297 (Brault 1997, 169–70). SMR 33764 Booton.

Fess Cotised
91 *Or a fess double cotised Gules.* Pendant, shield-shaped, very corroded, suspension-loop broken. NCM 261.980. Frontispiece (a), this volume. SMR 14762 West Caister.

Fess Between
221 *Or a fess between two chevrons Gules.* Pendant, elaborate quatrefoil. FITZWALTER. SMR 32107 Diss.

96 *Sable a fess between two chevrons [Or].* Pendant, shield-shaped, very small fragments of black enamel survive, and remains of iron pin in suspension-loop. BAYNARD, Robert, of Great Hautbois, Norf. 1290, summoned against the Scots 1298, d.1299, ?or his son Robert, d.1330 (Brault 1997, 37). SMR 33610 East Walton.

194 *A fess indented ?Or/Argent voided [?] between three ?Bezants/Plates* (on a shield between three pairs of leaves conjoined). ?Mount, circular, enamel missing, pierced by rivet in rivet-hole above shield. NCM. Frontispiece (a), this volume. SMR 33389 ?Norfolk.

Gules a fess between six martlets (3,2,1) ?Or/Argent. Pendant, shield-shaped. BEAUCHAMP, Walter de (if *Or*), younger bro. of William de Beauchamp, Earl of Warwick, served against in Wales 1277, Steward of the King's household 1289–1303, d.1303 leaving s. and h. Walter (d.1303) who also sealed with these arms (Brault 1997, 41); or BURDET, Nicholas (if *Argent*), s. and h. of William Burdet of Shepey, Leic., living in 1296 (Brault 1997, 83). Photo NCM. SMR 23964 Great Ryburgh.

167 *Gules a fess between six crosses-crosslet (1,2,2,1) [Or].* Stud, lozengiform, shank on reverse. BEAUCHAMP, Earls of Warwick. KLM 99.963. SMR 4255 Shouldham.

227 *Gules a fess between six crosses-crosslet (1,2,2,1) Or.* Pendant, engrailed, six-sided. BEAUCHAMP, Earls of Warwick. SMR 7656 Hevingham.

216 *Gules a fess between six crosses-crosslet (1,2,2,1) [Or].* Pendant, elaborate quatrefoil, suspension-loop broken, replaced by drilling a hole further down the neck of original loop. BEAUCHAMP, Earls of Warwick. SMR 33606 Beeston with Bittering.

Fess Between and Label
90 *[Argent] a fess between two bars gemelles Gules a label of four points Azure overall.* Pendant, shield-shaped, black deposits on field ?silvering. ?BADLESMERE, Bartholomew de, of Badlesmere and Chilham Castle, Kent, d.1322 (Brault 1997, 23–4). SMR 29018 Hethersett.

On a Fess
Gules ?on a fess ?Or/Argent three roundels. Pendant, shield-shaped. ?MENDHAM PRIORY, Suff. (untinctured). SMR 31088 Weybourne.

126 *[Or] on a fess [Gules] three water bougets [Argent].* Stud, shield-shaped, shank on reverse, condition poor, small trace of decayed ?red enamel present. ?BINGHAM, Richard de, of Bingham, Clipston, and Kinoulton, Notts., Justice of gaol delivery Lincs., 1296, and Notts., 1297. d. before 24th Aug. 1311 (Brault 1997, 54). SMR *** Salle.

Fish
Two Barbels

Gules semy of crosses two barbels haurient addorsed Or. Pendant, shield-shaped. ?BARRE, de. SMR 11788 Hopton on Sea.

Fleur-de-lis
2 *A ?fleur-de-lis.* Pendant, shield-shaped ('almond-shaped' shield), bent with engraved decoration, some gilding remains, once overall. (Goodall A.R. 1992, 95 and fig.116 no.17). SMR 5759 Congham.

A fleur-de-lis (within a lozengiform field). ?Mount, square, with lobed edges. SMR 25765 Congham.

A fleur-de-lis (on a circular field). Pendant, lozengiform. SMR 30867 Colkirk.

192 *Azure a fleur-de-lis Or.* Suspension-mount, circular with three rivet-holes and twin suspension-loops. SMR *** Gimingham.

234 *Or a fleur-de-lis [?]* (on a lozengiform field). Pendant, lozengiform with five (of originally eight) projecting arms, those crosswise ending in scallop-shaped terminals (one missing) the uppermost sumounted by a suspension-loop, and those saltire-wise ending in

fleur-de-lis terminals (two missing). Greenish decayed enamel, original tincture now unidentifiable, survives within the fleur-de-lis. SMR 5391 Shotesham.

181 *[?] A fleur-de-lis Or.* Stud, ?square, shank on reverse, enamel missing, very bent and incomplete. SMR *** Burnham Thorpe.

Azure a fleur-de-lis Or (circular field set within incised radiating lines, gilt). Pendant, square. ?AGILON or ?FLORE. Photo NCM. SMR 3066 North Tuddenham.

244 *Azure a fleur-de-lis [Or].* Hooked bar-mount, facetted bar, central square plate with enamelled decoration, two further square plates each with incised lozengiform decoration, one above, one below, the lower pierced by rivet-hole; the top of the bar has a pierced facetted terminal and long knop, the foot terminates with an animal-headed hook; bent, traces of silvering (and ?gilding on central square). ?FRANCE. Photo NCM. SMR 31087 Postwick.

Three Fleurs-de-lis
109 *Azure three fleurs-de-lis Or* (shield described by an engraved line within a bordure Or displaying rocker-arm decoration). Pendant, shield-shaped, bent, condition poor, ?beginning of secondary suspension-hole at foot of shield on reverse. ?FRANCE modern (with bordure ?for difference), or ?MONTGOMERY. SMR 33925 Haveringland.

179 (i) *Azure three fleurs-de-lis [Or]* (ii) *Gules a triple-towered castle [Or]* (on two shields, side by side). Mount, rectangular with four rivet-holes and a recent break. The arms are possibly allusive for Alphonse, Count of POITOU (d.1271 without issue), sixth son of Louis VIII of France, and Blanche of CASTILLE: *Azure semy-de-lis Or dimidiating Gules semy of castles triple-towered Or.* SMR 30636 Bradenham.

Semy-de-lis
[Azure] semy-de-lis [Or] (three fleurs-de-lis remaining). Pendant, broken, bottom quarter missing. ?FRANCE ancient. Photo NCM. SMR 15458 Costessey.

Flower
Rosette Within
Gules a rosette within a bordure ?engrailed/invected Or. Stud, shield-shaped, shank on reverse. SMR 30475 Postwick.

Gules a rosette within an ?orle of six fleurs-de-lis ?Or/Argent. Pendant, ?circular six-lobed, each lobe in the form of a fleur-de-lis, from the uppermost of which spings the suspension-loop, and that in base is broken. SMR 30558 Ringstead.

Flower and Over All
85 *Or a two-stemmed flower surmounted by a horse passant [?].* Pendant, shield-shaped, with suspension-stud, shank on reverse, attached by iron pin, very worn. Greenish decayed enamel and traces of gilding survive. SMR 24776 Fransham.

Foil
Trefoil
[?] A trefoil Or. Pendant, quatrefoil, suspension-loop broken. Photo FAD. SMR 30034 Gayton.

Quatrefoil
246 *?Or/Argent a quatrefoil Gules.* Pendant, elaborate lozengiform, suspension-loop broken. SMR 32304 Ketteringham.

Azure a quatrefoil Or (within a pelleted border). Pendant, elaborate lozengiform, a ?trefoil springing from each side, with matching suspension-stud with two rivet-holes and an 'H'-shaped lug. Photo NCM. SMR 30663 Hellesdon.

Sexfoil
19 *Argent a sexfoil Gules* (on a square field, four ?trefoils/fleurs-de-lis springing from the sexfoil into each corner of the field). Suspension-mount, square with double loop and flanking arms each ending in double loop terminals, each with remains of iron pin, rectangular projections at top and foot pierced by rivet-holes, one detached rivet found with mount. Part of an elaborate set found on same site (see drawings **20**, **21**, **22**, **23** and **24**). SMR 1058 Sporle with Palgrave.

Gules a ?sexfoil ?Or/Argent (within a lozenge, a fleur-de-lis springing from each point into each foil between four triangles Azure). Pendant, elaborate quatrefoil. Photo NCM. SMR 28320 Grimston.

214 *Gules a sexfoil ?Or/Argent* (within a lozenge a fleur-de-lis springing from each point into each foil Gules between four triangles Azure). Pendant, elaborate quatrefoil with circular attachment stud, shank on reverse, and iron pin, blue enamel and flecks of red enamel (now mostly mutated into green) present. NCM 174.976. SMR 7754 Haveringland.

Three Cinquefoils
97 *[Argent] three cinquefoils slipped Gules and pierced [Argent].* Pendant, shield-shaped, attached to suspension-stud, shank on reverse, by iron pin, traces of silvering on suspension-stud. ?DARCY, of Lincs., either Norman Darcy, d.1296, Philip (Norman's s. and h.), d.1333, or one of two Thomases (Norman's uncle, or his brother) d.1296 or d.1299 (Brault 1997, 134–5). SMR 34267 Spixworth.

Fret
9 *A fret* (decorated with stamped annulets within incised lines). Pendant, circular, with four lobes (one missing), traces of gilding, probably once overall. NCM 16.179.950. SMR 33389 ?Norfolk.

16 *A fret.* Mount, originally ?rectangular, bent, with ?four rivets, one of which survives. Traces of gilding, probably once overall. SMR 19223 Harling.

Fretty

6 *Fretty.* Suspension-plate, ?rectangular, broken, with pendant (see under **Star**), annular, attached, both decorated with incised lines and punched annulets and pierced by rivet-holes. Redrawn from original in file. SMR 19145 Roudham.

94 *[?] Fretty ?Or/Argent.* Pendant, shield-shaped, enamel missing, suspension-loop broken, remains of secondary rivet, used for re-attachment, in hole through body of shield. SMR 30650 Scole.

Fretty and Chief

53 *Or fretty on a chief [Sable] three bezants.* Pendant, shield-shaped. T.988.106. ST AMAND, Aumaury de, senior, d.1285, and Aumaury de, junior, d.1310 (Brault 1997, 370). Slide NCM. SMR 17271 Thetford.

170 *[Sable] fretty [Or] on a chief [Sable] a lion passant guardant [Or]* (on a shield set within silvered lozengiform decoration). Pendant, square, bent, decayed enamel, (now pale green), and silvering on suspension-loop survive. Traces of identical decoration on reverse, ?intentionally double-sided. ?MYLTECOMBE, Myttecombe. SMR 29132 Little Snoring.

Fusils

Three Fusils

82 *Argent three fusils cojoined in fess Gules.* Pendant, shield-shaped, recent (post-discovery) red and green overpainting of fusils and field. MONTAGU, Simon de, seals of 1293 and 1301, William de, seals of 1304 and 1316 (Brault 1997, 297). SMR 31109 Postwick.

178 *Per fess Gules and Argent three fusils cojoined in chief Argent* (on a shield set upon a circular field Azure, within incised gilt lozengiform decoration in border). Mount, square with rivet-hole in each corner, bent. SMR 21872 Mundham.

Gyronny

Gyronny Within

60 *Gyronny of twelve Gules and Argent a bordure Sable semy of roundels Or.* Pendant, shield-shaped. PEVEREL, Thomas, of Berton by Swathling, Hants., and of Blachington and Ripe, Suss., s. and h. of Andrew Peverel (d.1274), summoned against the Welsh, 1277 and 1282, and against the Scots 1297, 1298, 1300 and 1301, d.1306 leaving a s. and h. Andrew (Brault 1997, 340). Photo FAD. SMR 33837 Blakeney.

Head

163 *Per bend Azure and Gules the head of a ?king crowned ?Argent.* Pendant, elaborate lozengiform, with eight projecting lobes from the uppermost of which sprung the suspension-loop (now missing), very worn, traces of silvering on sides. SMR 33372 Mattishall.

Bust with vine scroll. Pendant, gilt. SMR 2634 Oxborough.

229 *Gules a hart's head cabossed Or* (on an octagonal field within Azure an orle of eight sexfoils Or). Pendant, engrailed octogon, with iron pin and suspension-stud, shank on reverse. NCM 476.978. (Margeson 1979, 227). Frontispiece (a), this volume. SMR 4396 West Dereham.

A lion's head couchant (within radiating engraved lines). Pendant, circular, gilded (possibly overall), with pierced suspension-arm ending in trefoil terminal. Photo NCM. SMR 30426 Mundham.

[?] A stag's head cabossed ?Or. Pendant, elaborate quatrefoil, traces of gilding survive. Slide NCM. SMR *** ?Norfolk.

Azure a stag's head cabossed Or (within trefoil, red enamel filling remaining triangular spaces outside field). Pendant, circular. ?BROWTON, Boughton or ?DERHAM, Norf. SMR 13043 Kettlestone.

Or a stag's head cabossed Gules. Pendant, octagonal. SMR 18499 Horsham St Faith.

Head Within and in Chief and in Base

224 *Gules a head of ?Christ within an orle of ?triangles or ?mitres a cross lozengy in chief and in base ?Or/Argent.* Pendant, engrailed octagon, with circular attachment stud (now detached), shank on reverse, traces of iron pin in suspension-loops, red enamel now mostly decayed and mutated into light green. NCM 103.983. cf. Norfolk Archaeol. 7, 349, for very similar design on ?mount, described as being from the ?centre of a bowl (Fitch Collection, NCM 76.94.235). SMR 33393 Martham.

Human

Mounted figure with sword arm raised ?Or/Argent (on a pelleted ground). Pendant, circular. SMR 31340 South Lopham.

Gules a king enthroned crowned and sceptred ?Or/Argent (white enamel in arms of figure) (on a circular field). Pendant, circular, with six scallop-shaped projecting lobes from the uppermost of which springs the suspension-loop, pierced at base by ?secondary rivet-hole. Photo NCM. SMR 4250 Swafield.

Gules a king enthroned crowned and sceptred ?Or/Argent. Pendant, within cinquefoil frame *cf.* LMMC fig. 39 (2). Rivet through throne. SMR 9836 Caistor St Edmund.

Human Between

Gules a human figure holding a sword between mullets ?Or. Pendant, incurving sides with H-shaped suspension-mount, spike on reverse. SMR 11707 North Creake.

?Knot

15 *A ?knot.* Suspension-plate, square, flanked by two rectangular lugs, each pierced by a rivet-hole, one of

which is broken, and two suspension-loops at base. SMR 31726 Field Dalling.

Label

87 *?Or/Argent a label Gules* (for obverse of pendant and description see under **Bird**). SMR 29896 Attleborough.

Leaf

A leaf ?Argent. Stud, circular, ?silvered, with spike on reverse. SMR 15795 Burgh Castle.

Leaves

Three Leaves

Three oak leaves (within a border of punched dots). Pendant, lozengiform, ?enamel missing, suspension-loop broken. SMR 11788 Hopton on Sea.

[?] Three leaves ?Or/Argent. Pendant, ?circular with three lobes, ?enamel missing, suspension-loop missing. SMR 30600 Beetley/Stanfield.

231 *Azure three leaves conjoined in base Or.* Pendant, circular, six-lobed, each lobe fleury, suspension-loop broken, pierced at the foot by a rivet-hole, rivet present with rove on reverse. NCM 262.980. Frontispiece (a), this volume. SMR 15999 Postwick.

Letter

191 *The letter 'R' from which spring three palm leaves ensigned with an open crown and two further leaves above.* Mount, circular, shank on reverse, edge damaged, gilding survives on border, possibly once overall. SMR 31571 Binham.

228 *Gules a lombardic letter 'M' Or.* Pendant, engrailed octagon, loop and one point broken. NCM 477.978. (Margeson 1979, 228). SMR 14100 Reedham.

Gules a letter 'T' Or/Argent. Pendant, lozengiform. SMR 17589 Little Snoring.

?Lozenges

Five ?Lozenges

8 *Five ?lozenges crosswise Or.* Pendant, circular with six (?originally seven) small projecting lobes, very worn, with no trace of original surface treatment of field. SMR 31727 Shipdham.

Lozengy

Lozengy. Mount, circular with pierced rectangular projection at ?top, broken at ?foot, gilded overall, with incised lines and zones of stamped decoration. SMR 19927 Howe.

107 *Lozengy Gules and ?Or/Argent.* Pendant, shield-shaped, patch of iron-staining at top of shield. ?TIDENHAM, of Norf. (if *Argent*). (BFAC, 53 no.38), (CMAG no.154). NCM 227.76.94, (Rye 1909 no.979), Fitch Collection. Frontispiece (a), this volume. SMR 33388 Norfolk.

Mascules

Seven Mascules and Label

43 *Gules seven mascules conjoined (3, 3, 1) a label of four points overall Or.* Pendant, shield-shaped, suspension-loop broken. QUINCY, Roger de, (without label), Earl of Winchester, d.1264 without issue, arms then assumed, by descent, through the marriage of Roger's sister Margaret De Quincy to Lord FERRERS, seventh Earl of Derby, by Lord Ferrers (of Groby), her second son, (Brault 1997, 457). SMR 31561 Foxley.

Mitres

Three Mitres

158 *Azure three mitres (2, 1) Or and Gules labelled Or.* Pendant, lozengiform, remains of iron pin in suspension-loop. Bishopric of NORWICH. SMR 7656 Hevingham.

199 *Azure three mitres (2, 1) labelled [Or].* Pendant, quatrefoil, suspension-loop missing. Bishopric of NORWICH. SMR 24414 Marsham.

Azure three mitres (2,1) Or and Gules labelled ?Or. Pendant, lozengiform. Bishopric of NORWICH. Slide NCM. SMR 8446 Horning.

Monster

Dragon Couchant Regardant

182 *[?] A dragon couchant regardant.* Stud, square, shank on reverse, enamel and surface treatment missing. SMR *** Roudham.

Griffin

201 *Azure a griffin passant Argent.* Pendant, quatrefoil, with suspension-stud, shank on reverse, attached by iron pin. SMR 30729 Quidenham.

202 *Azure a griffin passant Argent.* Pendant, quatrefoil, iron-staining around suspension-loop. SMR 3924 Pentney.

86 *?Or/Argent a griffin segreant [?].* Pendant, shield-shaped, enamel missing. (BFAC, 53 no.40). NCM 226.76.94, (Rye 1909 no.981), Fitch Collection. Frontispiece (a), this volume. SMR 33388 Norfolk.

240 *?Or/Argent a griffin segreant Azure armed Gules.* Banner, rectangular, decorated on both sides, griffin to sinister on reverse. ?HARGOST (if *Argent*). KLM 1993.18. SMR 32085 Oxborough.

Gryllus

154 *Azure a gryllus hooded ?Or/Argent and Gules.* Pendant, lozengiform. SMR 31497 Cranworth.

155 *Azure a gryllus hooded ?Or/Argent and Gules.* Pendant, lozengiform. Slide FAD. SMR 21470 Beachamwell.

?Monster

17 A *?monster maculate passant to sinister*. Pendant, oval, gilded (probably once overall), slightly bent. NCM 84.979. SMR 9308 Costessey.

Unicorn

A unicorn maculate. Pendant, shield-shaped, with small suspension-mount. Pers. comm. N.G. SMR 32265 'Thetford'.

77 *Or a unicorn rampant Azure voided ?Or/Argent maculate Gules armed Gules voided ?Or/Argent**. Pendant, shield-shaped, very small trace of gilding on field. *Alternatively, the unicorn depicted on the arms described above could, perhaps, be described as being *in ombre* (that is, as a ghost or shadow), the earliest previously known English examples of which blazon date to the second decade of the fifteenth century (London 1949a, 141–2, 9). SMR 32309 Narford.

Wyvern

A ?wyvern. Mount, gilded, with iron attachment spike. Photo KLM (not seen). SMR 21449 Bircham.

A ?wyvern (or winged creature, on a field of gilded rosettes). Mount, one surviving rivet in lobe. SMR 28574 Ashmanhaugh.

Wyvern ?Sejant Regardant

18 *Azure a wyvern ?sejant regardant Or*. Pendant, circular, very small piece of gilding present. NCM 19.982 (i). SMR 17940 Costessey.

Wyvern Queue Forchee

20 A *wyvern queue forchee passant to the sinister*. (For description see no.**20** under **Lion Passant Guardant Within**). Part of an elaborate set found on the same site (see drawings **19**, **21**, **22**, **23** and **24**). SMR 1058 Sporle with Palgrave.

21 A *wyvern queue forchee passant to the sinister*. Suspension-mount, square, gilded overall, with two semi-circular lugs pierced by rivet-holes, and suspension-loops with remains of iron pin. Part of an elaborate set found on same site (see drawings **19**, **20**, **22**, **23** and **24**). Photo NCM. SMR 1058 Sporle with Palgrave.

26 A *wyvern queue forchee passant to the sinister*. Pendant, square, worn, with traces of gilding, probably once overall. SMR 33204 Woodton.

Mount
Within a Mount

230 *Within a mount a tree*. Pendant, triangular, bent, suspension-loop missing, incised decoration, original surface treatment lost. SMR 1826 Warham.

Triple Mount

4 A *triple mount* (engraved rocker-arm decoration within each mount). Pendant, shield-shaped ('kite-shaped' shield), gilding present (once overall) in engraved decoration and also in patches on the field. SMR 3150 Reepham.

Mullet

34 *Gules a mullet of six points Or* (on a circular field, surrounded by moulded decoration). Pendant, square, suspension-loop missing, small traces of gilding survive mostly on reverse). Found on moated site, SMR 7625 Buxton with Lammas.

Pall
Pall Within

149 [?] *A pall within a bordure ?Or/Argent*. Mount, shield-shaped, constructed from two pieces of sheet ?soldered together, ?enamelling, or other treament of field, missing. (CMAG, no.157). NCM 225.76.94, (Rye 1909 no. 977). SMR 33389 ?Norfolk.

Paly
Paly and Chief and Label

45 *Paly Gules and Vair in pale on a chief [Or] a label of five points Azure*. Pendant, shield-shaped, suspension-loop missing, bent, surface treatment of metal missing. ?TOUCY, probably for a relative of Otton de Toucy, crusader, 1296, and his son Otton II, sire de Toucy (Yonne), admiral of France, 1296, d.1296, *Paly Gules and Vair on a chief Or three mullets Sable*, and, *Gules three pales Vair on a chief Or three martlets Sable* or Jean de Toucy, sealed with *Gules three pales Vair on a chief Or four martlets Sable* 1238 (Brault 1997, 418). SMR 34245 Tharston.

Quarterly

232 *Quarterly Gules and Azure*. Pendant, circular, with four scallop-shaped projections, some traces of gilding survive. SMR 25690 Bylaugh.

83 *Quarterly 1 [?] a lion rampant Or/Argent 2 and 3 ?Or/Argent 4 [?]*. Pendant, shield-shaped, very worn, enamel missing, suspension-loop broken. SMR 31774 Sparham.

226 *Quarterly 1 and 4 Azure semy-de-lis Or (France Ancient) 2 and 3 Gules three lions passant guardant Or (England)*. Pendant, engrailed octagon. ENGLAND *c*.1340–1405. SMR 32955 Shipdham.

Quarterly 1 and 4 a fleur-de-lis 2 and 3 a cross fleury. Strap-distributor, cylindrical with decorated (?niello) top and four rectangular holes in sides. SMR 20100 Shotesham.

Quarterly Within

Quarterly Gules and ?Or/Argent 1 a mullet within a bordure engrailed ?Or/Argent. Stud, shield-shaped, shank on reverse, with rove. Photo NCM. SMR 29670 Horning.

223 *Quarterly [Or] and [Gules] within a bordure Vair* (surrounded by four wyverns). Mount, elaborate quatrefoil, enamel missing, pierced by five attachment holes, that at the top of the mount probably secondary. Geoffrey FITZ-PIERS, Earl of Essex, ob.1213 and descendants FITZ-GEFFREY and FITZ-JOHN. Family previously misidentified on ?nineteenth century label on reverse and in 1936 exhibition

catalogue as Hoo. (BFAC, 53 no.43), (CMAG, no.76). NCM (Rye 1909 no.986). SMR 33390 Mulbarton.

Saltire
Or a saltire Azure. Pendant, square, suspension-loop broken. Photo NCM. SMR 23800 Fleggburgh.

Saltire Engrailed
49 *Argent a saltire engrailed Gules*. Pendant, shield-shaped, suspension-loop missing. ?Botched or trial attempt at engraving an engrailed saltire on reverse. TIPTOFT, or Tibetot, Robert de, of Langer, Notts. (d.1298), and descendants, held lands in Suff., Lincs., and Yorks. (Brault 1997, 415). (*cf.* Alexander and Binsky (Eds) 1987, 258–9, no. 162 and Griffiths 1986a, 221–3, fig.1b). SMR 32738 East Rudham.

[Argent] a saltire engrailed [?]. Pendant, shield-shaped. ?TIPTOFT. (Illustrated in Griffiths 1986a, 221–3, fig.1b). SMR 32264 'Norfolk'.

46 *Or a saltire engrailed Gules*. Pendant, shield-shaped. MOIGNE, John le, of Suff., Knight of the shire, Hunts.1290, Cambs.1303, summoned against the Scots 1301, d.1342 (Brault 1997, 295). Photo NCM. SMR 30362 Quidenham.

52 *Or a saltire engrailed Gules*. Pendant, shield-shaped. MOIGNE, John le, of Suffolk, Knight of the shire, Hunts.1290, Cambs.1303, summoned against the Scots 1301, d.1342 (Brault 1997, 295). SMR 31109 Postwick.

Saltire Between
[?] A saltire between four fleur-de-lis ?Or/Argent. Pendant, elaborate lozengiform, arms of saltire extend to form lobes on sides of pendant, also present on side and bottom points. Photo NCM. SMR 20478 Horsham St Faith.

Saltire and Chief
A saltire engrailed on a chief two crescents. Pendant, lozengiform. Pendant was seen briefly by SJA, but subsequently 'lost' by finder before a drawing or full blazon could be made, enamelling present but no note taken of tinctures. SMR 31587 Ashill.

On a Saltire
Gules on a saltire ?Or/Argent eight cross crosslets [?]. Pendant, shield-shaped. SMR 2812 Beetley.

Gules on a saltire Or/Argent ?trefoils [?]. Pendant, shield-shaped, suspension-loop broken. SMR 20198 Shotesham.

Star
13 *A star of six points*. Pendant, elaborate hexagonal lobed, openwork six-pointed star with central boss, surrounded by triangular zones of stamped annular decoration between four convex lobes. Gilding survives in incised and stamped decoration, once overall. SMR 30472 Postwick.

7 *A star of six points*. Suspension-mount, circular, pierced in centre, with suspension-loops, decorated with incised lines and stamped annulets, gilding survives, once overall. A pendant, circular, pierced in centre with rivet-hole, rivet in place, bearing the same decoration as described above, is suspended from the mount by a copper-alloy pin. SMR 34456 Reepham.

12 *A star of six points*. Pendant, circular, lobed (three of originally four lobes survive), bent and broken, rivet-hole with rivet immediately below suspension-loop, stamped and engraved decoration, traces of gilding, once overall. SMR 33249 Wiveton.

6 *A star of six points*. Pendant (for description see under **Fretty**). SMR 19145 Roudham.

11 *A star of ?six points*. Pendant, circular, lobed (one of originally ?four lobes survives), broken into two, one upper lobe and lower third of pendant missing, rivet-hole immediately below suspension-loop, stamped and engraved decoration, traces of gilding, once overall. SMR 15060 Wickmere.

10 *A star of eight points*. Pendant, four-lobed, bent, stamped and engraved decoration, traces of gilding, probably once overall. SMR 32872 Cawston.

193 *A star of eleven points*. ?Pendant/mount, circular, traces of gilding (once overall), pierced by ?suspension-hole. SMR 31679 Quidenham.

Tree
A ?tree three branches conjoined in base. ?Mount, circular with six projecting circular lobes. Photo NCM. SMR 25819 Alburgh.

Gules ?three branches pale-wise ?Or/Argent (extending into each lobe). Pendant, trefoliate. SMR 18456 Trowse with Newton.

Tree Between
32 *Per pale Azure and Gules a ?three-limbed tree each limb ending in a bunch of grapes cojoined in base between four annulets Or*. Pendant, square, traces of iron around suspension-loop. SMR 30450 Sparham.

Tree and Over All
151 *Argent a tree Azure surmounted by a martlet Gules*. Pendant, lozengiform. SMR 20513 Ludham.

Gules a tree surmounted by a lion passant guardant Or. Stud, circular with shank on reverse and four secondary holes around edge, three with rivets surviving. Photo NCM. SMR 29340 Guist.

152 *[?] A three branched tree surmounted by a lion couchant guardant Argent*. Pendant, lozengiform, remains of iron pin in suspension-loop also traces of red and green discolouring (?enamel) on field. SMR 31664 Bintree.

153 *?Or/Argent a three branched tree surmounted by a lion couchant guardant Argent*. Pendant, lozengiform,

remains of iron pin in suspension-loop. SMR *** Shouldham.

243 *Or a three-branched tree surmounted by a lion couchant guardant Argent* (Lion to sinister on reverse). Banner, lozengiform. Photo NCM. SMR 4360 Fincham.

Or a ?tree Azure surmounted by a ?beast Argent. ?Mount, shield-shaped, ?broken. SMR 25466 Little Walsingham.

Trumpets

Azure crusily two trumpets pilewise [Or]. Pendant, shield-shaped, attached to cruciform suspension-mount (? by iron pin), upper and horizontal bars pierced by rivet-holes. TRUMPINGTON, de, Roger (d.1289) or Giles (his s. and h.) of Trumpington, Cambs. *Treasure Hunting*, Nov. 1995, 54. SMR 34249 'Norfolk'.

Vair

98 *Vair ?Or/Argent and [?].* Pendant, shield-shaped, enamel missing, suspension-loop broken. SMR 32022 Ashill.

Vair-en-point

105 *Vair-en-point Or and [?].* Pendant, shield-shaped, suspension-loop broken, enamel missing. Found in association with a cruciform suspension-mount, three rivet-holes, one broken, uppermost with rivet surviving with rove, gilt, iron pin in suspension-loop. SMR 34250 Ingoldisthorpe.

Vair-en-point and Label

159 *Vair-en-point Or and Gules a label of the first each point charged with two bars and fimbriated Azure.* Pendant, lozengiform, traces of iron pin in suspension-loop. Paired with identical pendant from same site (following entry, drawing **160**). SMR 31127 Emneth.

160 *Vair-en-point Or and Gules a label of the first each point charged with two bars and fimbriated Azure.* Pendant, lozengiform, traces of iron pin in suspension-loop. Paired with identical pendant from same site (preceeding entry, drawing **159**). SMR 31127 Emneth.

Wheel

Gules a ?catherine wheel with cruciform spokes and concentric anti-clockwise rays Or voided Azure (alternatively *A cross within a crown of thorns* as suggested by Griffiths 1995 for a similar pendant, no.71, 67–8, fig.50). Pendant, circular, eight-lobed (leaf-shaped) with suspension-loop springing from uppermost. Slide NCM. SMR 17777 Harling.

[?] A ?catherine wheel with cruciform spokes and concentric anti-clockwise rays ?Or/Argent (alternatively *A cross within a crown of thorns* as suggested by Griffiths 1995 for a similar pendant, no.71, 67–8, fig.50). Pendant, circular, eight-lobed (two missing) with suspension-loop springing from uppermost, enamel missing. Photo NCM. SMR 30194 Shelton.

Wings

99 *?Or/Argent a pair of wings inverted [?].* Pendant, shield-shaped, unfortunately severely cleaned since discovery, consequently all surface treatment missing. SMR *** Norfolk.

Appendix 2: Armory

Illustration numbers are shown in bold type. Page numbers within the Ordinary are given for unillustrated examples.

AGILON 47

ALNWICK, Bishop **148**

ASHPOLE, Sir John of Essex **185**

BADLESMERE, Bartholomew de, of Badlesmere and Chilham Castle, Kent **90**

BARRE, de 46

BAYNARD, Robert, of Great Hautbois, Norf., Knight of the Shire, Norf. **96**

BEAUCHAMP, Earls of Warwick **167, 216, 227**

BEAUCHAMP, Walter de, Steward of the King's household 46

BELER, of Kirby Beler 37

BIGOD, Roger le, Earl of Norf. and Marshall of England 35

BINGHAM, Richard de, of Bingham, Notts, Justice of gaol delivery Lincs. and Notts. **126**

BRAOSE **74**

BROCBURN 41

BURDET, Nicholas 46

BLUET 40

BOHUN, de, Earls of Hereford and Essex **68, 69, 80, 81, 122, 123, 124,** 39, 40

BOUN, John de **115**

BREWS, Thomas de 36

BROCBURN ******

BROWTON 48

BURY ST EDMUNDS 45

CASTILLE **245**

CASTILLE, Blanche of **179**

CHAMPAGNE, Henry and Blanche, Count and Countess of ******

CLARE, de, Earls of Gloucester and Hereford **48, 59, 147,** 42

CLIFFORD, Robert and Roger de **58, 129**

COLEVILE, Sir John, of Norf. **75**

CRANEMERE **166**

DARCY, of Lincs **97**

DELAMARE **172**

DERHAM, of Norf. 48

ECCLESHALL 39

ELY, Bishop of **66, 196, 197, 198,** 45

ENGLAND **38, 39, 40, 50, 51, 55, 56, 57, 67, 103, 111, 127, 128, 131, 180, 186, 207, 215, 226, 238, 242,** 38

ENGLAND and FRANCE, allusive for **203, 204, 205, 207, 208, 209, 210, 211, 212, 213, ??214, ?215,** 34, 35

FELBRIGG, of Felbrigg, Norf. **146, 161**

FERRERS, Earl of Derby **43**

FITZGEFFREY **223**

FITZJOHN **223**

FITZJOHN, Robert, Sheriff of Norf., and Constable of Norwich Castle **144**

FITZPIERS, Earl of Essex **223**

FITZWALTER **221**

FLORE 47

FRANCE **109, 192, 244,** 47

FREVILLE, Baldwin de, Wellingham, Norf. **44**

GREY, de **164**

GRINDALE, Robert de **101**

GUYENNE, Duke of **171**

HAINALT, Philippa de (wife of Edward III) **106**

HALES, Mill Steph. of Holt, Norf. **239**

HARGOST **240**

HATTON **134**

HENGRAVE, Edmund de, of Hengrave, Suff., Sheriff of Norf. and Suff. and keeper of Norwich Castle **104, 133**

HOLLAND, Earl of Kent **186**

INGHAM, ?Oliver de, of Ingham, Norf. **62**

LANCASTER, Thomas, Earl of, or Henry, Duke of 38

LEYBOURNE, de **79**

LIMESY, Ralph de 41

LINDSAY, ?Philip de **130**

MENDHAM Priory 46

MOHAUT, Robert de, of Castle Rising, Norf. **75**

MOIGNE, John le, of Suff. **46, 52**

MONTAGU, Simon and William de **82**

MONTGOMERY **109**

MOONE **43**

MORLEY **225**

MYLTECOMBE **170**

MULTON, Hubert de, of Surlingham, Norf. **117, 118, 119, 125**

NAVARRE and CHAMPAGNE 45

NEVILLE 36

NORMANDY **172**

NORWICH, Bishop of **157, 158, 199,** 45, 49

OGAND **168, 169**

PERCY, Bishop of Norwich 37
PEVEREL, Thomas, of Berton by Swathling, Hants., and of Blachington and Ripe, Suss. **60**
POITOU, Alphonse, Count of **179**
PYKERYNG 37
QUINCY, Roger de, Earl of Winchester **43**
REYMES, John de, Senior, of Norf. **239**
REVIERS, Earl of Devon, 34
ROSSELYNE, Sire William, of Norf. **89**
ROTHING, John de, 34
ST AMAND, Aumaury de **53**
SAINT EDMUND **66**
SAINT EDWARD **217, 218**
SAINT DAVIDS, Bishop of 44–5
SAINT GEORGE **36, 41, 113**
SCHOLDHAM, Sr [sic] de Wolverton 40
SOMERY, Henry de, of Essex 39
SOUTHWOLD 45

SUMERI **87,** 41
SUTTON **162**
TALBOT, Richard of Eccleswall, Here., Sheriff of Glou. 40
TIDENHAM, of Norf. **107**
TIPTOFT, of Notts. and Suff. **49,** 51
TOUCY, de **45**
TRUBLEVILE, of Normandy, and the manor of Sherbourne **173**
TRUMPINGTON, Roger and Giles de 52
UFFORD, Robert de, of Suff. 43
VALOINS, of Norf. 36
VANE, of Norf. **108**
WAKE **57**
WARENNE, Earls of Surrey **1, 92, 142,** 41
WATERVILLE, Robert de 42
WEYLAND, of Suff. **72**
WINCHELSEA **206**

Appendix 3: List of Illustrated Finds with their Blazons

The finds are listed in order of drawing number. Each number is followed by a blazon of the arms displayed upon the find, the number of the figure containing the artefact drawing, and the page number on which a description of the object can be found. Finds with more than one coat of arms have more than one entry.

1	Checky	Fig.6	p.6
2	A ?fleur-de-lis	Fig.6	p.6
3	A ?cross engrailed	Fig.6	p.6
4	A triple mount	Fig.6	p.6
5	A lion rampant	Fig.6	p.6
6	A star of six points	Fig.6	p.6
6	Fretty	Fig.6	p.6
7	A star of six points	Fig.6	p.6
7	A star of six points	Fig.6	p.6
8	Five ?lozenges crosswise Or	Fig.6	p.6
9	A fret	Fig.6	p.6
10	A star of eight points	Fig.6	p.6
11	A star of ?six points	Fig.6	p.6
12	A star of six points	Fig.6	p.6
13	A star of six points	Fig.6	p.6
14	Barry of six	Fig.7	p.7
15	A knot	Fig.7	p.7
16	A fret	Fig.7	p.7
17	A ?monster maculate passant to sinister	Fig.7	p.7
18	Azure a wyvern ?sejant regardant Or	Fig.7	p.7
19	Argent a sexfoil Gules	Fig.8	p.8
20	A lion passant guardant within an annulet fleury	Fig.8	p.8
20	A wyvern queue forchee passant to the sinister	Fig.8	p.8
21	A wyvern queue forchee passant to the sinister	Fig.8	p.8
22	A lion passant guardant within an annulet fleury	Fig.8	p.8
23	A lion passant guardant within an annulet fleury	Fig.8	p.8
24	A lion passant guardant	Fig.8	p.8
25	A lion passant guardant to sinister within an annulet fleury	Fig.9	p.9
26	A wyvern queue forchee passant to the sinister	Fig.9	p.9
27	A lion passant to sinister within an annulet fleury	Fig.9	p.9
28	A lion passant guardant to sinister within an annulet/tressure fleury	Fig.9	p.9
29	Between two lions combatant a staff fleury	Fig.9	p.9
30	A winged ?bull couchant regardant to the sinister	Fig.9	p.9
31	An escutcheon	Fig.9	p.9
32	Per pale Azure and Gules a ?three-limbed tree each limb ending in a bunch of grapes conjoined in base between four annulets Or	Fig.9	p.9
33	Quarterly Gules and Azure a cross Or overall	Fig.9	p.9
34	Gules a mullet of six points Or	Fig.9	p.9
35	Or a cross Gules	Fig.9	p.9
36	Argent a cross [?Gules]	Fig.9	p.9
37	Gules a cross Or	Fig.9	p.9
38	Gules three lions passant guardant Or	Fig.10	p.10
39	Gules three lions passant guardant [Or]	Fig.10	p10.
40	Gules three lions passant guardant Or	Fig.10	p.10
41	?Or/Argent a cross Gules	Fig.10	p.10
42	[?] A cross indented Or	Fig.10	p.10
43	Gules seven mascules co-joined (3, 3, 1) a label of four points overall Or	Fig.10	p.10
44	[Or] on a cross moline Gules five lozenges Vair	Fig.10	p.10
45	Paly Gules and Vair in pale on a chief [Or] a label of five points Azure	Fig.10	p.10
46	Or a saltire engrailed Gules	Fig.10	p.10
47	[?] A lion rampant to sinister ?Or/Argent	Fig.10	p.10
48	[Or] three chevrons Gules	Fig.10	p.10
49	Argent a saltire engrailed Gules	Fig.10	p.10
50	[Gules] three lions passant guardant [Or]	Fig.10	p.10
51	Gules three lions passant guardant [Or]	Fig.10	p.10
52	Or a saltire engrailed Gules	Fig.10	p.10
53	Or fretty on a chief [Sable] three bezants	Fig.10	p.10
54	Or on a chief Gules two mullets of six points Or pierced [?]	Fig.10	p.10
55	Gules three lions passant guardant Or	Fig.10	p.10
56	Gules three lions passant guardant Or	Fig.10	p.10

#	Blazon	Figure	Page
57	Gules three lions passant guardant Or impaling Or two bars and in chief three roundels Gules	Fig.11	p.11
58	Checky Or and Azure a fess Gules	Fig.11	p.11
59	Or three chevrons Gules	Fig.11	p.11
60	Gyronny of twelve Gules and Argent a bordure Sable semy of roundels Or	Fig.11	p.11
61	?Or/Argent a lion rampant Azure	Fig.11	p.11
62	Per pale ?Or and [?Vert] a cross recercelee Gules	Fig.11	p.11
63	Quarterly Or and Azure a bend Gules	Fig.11	p.11
64	Argent three bars Azure	Fig.11	p.11
65	Argent a chevron [?]	Fig.11	p.11
66	[?] Three crowns Or (2:1)	Fig.11	p.11
67	Gules three lions passant guardant [Or]	Fig.11	p.11
68	Azure a bend [Argent] cotised between six lions rampant [Or]	Fig.11	p.11
69	Azure a bend Argent cotised between six lions rampant [Or]	Fig.11	p.11
70	Or a peacock close crested [?and armed] [?Gules]	Fig.11	p.11
71	[?] A lion rampant queue forchee Argent	Fig.12	p.12
72	Azure a lion rampant Argent surmounted by a bend Gules	Fig.12	p.12
73	[?] A lion rampant ?crowned ?Or/Argent a label of of three points Gules overall	Fig.12	p.12
74	?Or semy of cross-crosslets a lion rampant queue forchee in saltire Gules crowned ?Or	Fig.12	p.12
75	Azure a lion rampant Argent	Fig.12	p.12
76	Gules three ?combs in pale ?Or/Argent	Fig.12	p.12
77	Or a unicorn rampant Azure voided ?Or/Argent maculate Gules armed Gules voided ?Or/Argent	Fig.12	p.12
78	Azure a ?lion passant guardant Or maculate Azure	Fig.12	p.12
79	Azure six lions rampant Argent	Fig.12	p.12
80	Azure a bend [Argent] cotised between six lions rampant [Or]	Fig.12	p.12
81	Azure a bend cotised between six lions rampant Or	Fig.12	p.12
82	Argent three fusils cojoined in fess Gules	Fig.12	p.12
83	Quarterly 1 [?] a lion rampant Or/Argent 2 and 3 ?Or/Argent 4 [?]	Fig.12	p.12
84	Or a hart trippant Argent attired Gules in base a ?hare Argent issuant from a mount Vert	Fig.12	p.12
85	Or a two-stemmed flower surmounted by a horse passant [?]	Fig.12	p.12
86	?Or/Argent a griffin segreant	Fig.12	p.12
87	?Or/Argent a label Gules	Fig.12	p.12
87	?Or/Argent a peacock in his pride Gules and [?]	Fig.12	p.12
88	Or a lion passant guardant bendwise between two quatrefoils slipped [?]	Fig.12	p.12
89	[?] Three fermaux ?Or/Argent a bend overall ?Or/Argent	Fig.13	p.13
90	[Argent] a fess between two bars gemelles Gules a label of four points Azure overall	Fig.13	p.13
91	Or a fess double cotised Gules	Fig.13	p.13
92	Checky Or and Azure	Fig.13	p.13
93	A ?fess	Fig.13	p.13
94	[?] Fretty ?Or/Argent	Fig.13	p.13
95	Sable a cross engrailed ?Or/Argent	Fig.13	p.13
96	Sable a fess between two chevrons [Or]	Fig.13	p.13
97	[Argent] three cinquefoils slipped Gules and pierced [Argent]	Fig.13	p.13
98	Vair ?Or/Argent and [?]	Fig.13	p.13
99	?Or/Argent a pair of wings inverted	Fig.13	p.13
100	?Or/Argent a bend ?cotised	Fig.13	p.13
101	Or on a cross [?] five mullets of six points Or pierced [?]	Fig.13	p.13
102	[?] A cross engrailed Or	Fig.13	p.13
103	Gules three lions passant guardant Or a label Azure overall	Fig.13	p.13
104	[Argent] a chief indented Gules	Fig.13	p.13
105	Vair-en-point Or and [?]	Fig.13	p.13
106	[Or] four lions rampant 1 and 4 Sable 2 and 3 Gules	Fig.14	p.14
107	Lozengy Gules and ?Or/Argent	Fig.14	p.14
108	?Or/Argent an escutcheon within an orle of eight martlets Gules	Fig.14	p.14
109	Azure three fleurs-de-lis Or	Fig.14	p.14
110	Or a lion rampant [?]	Fig.14	p.14
111	Gules three lions passant guardant Or	Fig.14	p.14
112	Gules a cross patonce Ermine	Fig.14	p.14
113	Argent a cross Gules	Fig.14	p.14
114	Or a cross Azure on a chief five bezants	Fig.14	p.14
115	Or a cross Azure	Fig.14	p.14
116	A lion rampant	Fig.14	p.14
117	Argent three bars Gules	Fig.14	p.14
118	Argent three bars Gules	Fig.14	p.14

119 *Argent three bars Gules*	Fig.14 p.14	**152** *[?] A three branched tree surmounted by a lion couchant guardant Argent*	Fig.17 p.17
120 *?Barry/paly of six Or and Gules*	Fig.14 p.14	**153** *?Or/Argent a three branched tree surmounted by a lion couchant guardant Argent*	Fig.17 p.17
121 *?Bezanty/platty*	Fig.15 p.15	**154** *Azure a gryllus hooded ?Or/Argent and Gules*	Fig.17 p.17
122 *Azure a bend [Argent] cotised between two lions rampant [Or]*	Fig.15 p.15	**155** *Azure a gryllus hooded ?Or/Argent and Gules*	Fig.17 p.17
123 *Azure a bend [Argent] cotised between two lions rampant [Or]*	Fig.15 p.15	**156** *?Or/Argent a chief indented Azure*	Fig.17 p.17
124 *Azure a bend [Argent] cotised between two lions rampant [Or]*	Fig.15 p.15	**157** *[?] A cross engrailed ?Or/Argent impaling Azure three bishops mitres [Or]*	Fig.17 p.17
125 *Checky Or and Gules a label overall ?Argent*	Fig.15 p.15	**158** *Azure three mitres (2, 1) Or and Gules labelled Or*	Fig.17 p.17
126 *[Or] on a fess [Gules] three water bougets [Argent]*	Fig.15 p.15	**159** *Vair-en-point Or and Gules a label of the first each point charged with two bars and fimbriated Azure*	Fig.17 p.17
127 *Gules three lions passant guardant [Or]*	Fig.15 p.15	**160** *Vair-en-point Or and Gules a label of the first each point charged with two bars and fimbriated Azure*	Fig.17 p.17
128 *Gules three lions passant guardant Or a label Argent overall*	Fig.15 p.15	**161** *Or a lion rampant Gules*	Fig.17 p.17
129 *Checky [Or] and Azure a fess Gules*	Fig.15 p.15	**162** *[Or] a lion rampant queue forchee Vert a bend company [Argent] and Gules overall*	Fig.17 p.17
130 *[Or] an eagle displayed Sable surmounted by a bend company [Argent] and [Gules]*	Fig.15 p.15	**163** *Per bend Azure and Gules the head of a ?king crowned ?Argent*	Fig.17 p.17
131 *Gules three lions passant guardant [Or]*	Fig.15 p.15	**164** *Barry of six ?Or/Argent and Azure*	Fig.18 p.18
132 *?Or/Argent a lion rampant [?]*	Fig.15 p.15	**165** *?Barry/paly of six [Or] and [Gules]*	Fig.18 p.18
133 *[Argent] a chief indented Gules*	Fig.15 p.15	**166** *Or a crane passant Gules*	Fig.18 p.18
134 *Ermine on a chevron Gules three mullets Or*	Fig.15 p.15	**167** *Gules a fess between six crosses-crosslet (1,2,2,1) [Or]*	Fig.18 p.18
135 *?Or/Argent two bends [?] a label overall*	Fig.15 p.15	**168** *Azure an estoile of eight points Or*	Fig.18 p.18
136 *Or on a chief Gules two mullets of six points Or pierced Gules*	Fig.15 p.	**169** *Azure an estoile of eight points Or*	Fig.18 p.18
137 *?Or/Argent a cross Gules a canton Ermine*	Fig.15 p.15	**170** *[Sable] fretty [Or] on a chief [Sable] a lion passant guardant [Or]*	Fig.19 p.19
138 *?Or/Argent a cross [Gules] a canton Ermine*	Fig.15 p.15	**171** *Gules a lion passant guardant Or*	Fig.19 p.19
139 *Or on a chief Azure two mullets Or*	Fig.15 p.	**172** *Gules two lions passant guardant ?Or/Argent*	Fig.19 p.19
140 *?Or/Argent a lion rampant [?]*	Fig.15 p.15	**173** *Azure a crowned lion passant guardant in dexter chief a cinquefoil in sinister chief and another in base Or*	Fig.19 p.19
141 *[?] A lion rampant ?Or/Argent*	Fig.15 p.15		
142 *Checky ?Or/Argent and Azure*	Fig.15 p.15		
143 *Or an eagle displayed Azure armed Gules*	Fig.15 p.15	**174** *Azure a cross of Toulouse Or voided Gules*	Fig.19 p.19
144 *Checky [Or] and Gules a fess Ermine*	Fig.15 p.15	**175** *Azure a cross fleury Or voided Azure*	Fig.19 p.19
145 *Gules an eagle displayed ?Or/Argent*	Fig.16 p.16	**176** *Azure a cross fleury Or voided Azure*	Fig.19 p.19
146 *Or a lion rampant Gules*	Fig.16 p.16	**177** *Azure a cross fleury Or voided Gules*	Fig.19 p.19
147 *Three chevrons*	Fig.16 p.16	**178** *Per fess Gules and Argent three fusils conjoined in chief Argent*	Fig.19 p.19
148 *[?] A cross fleury ?Or/Argent*	Fig.16 p.16		
149 *[?] A pall within a bordure ?Or/Argent*	Fig.16 p.16		
150 *A Cross potent*	Fig.17 p.17	**179** *(i) Azure three fleurs-de-lis [Or] (ii) Gules a triple-towered castle [Or]*	Fig.19 p.19
151 *Argent a tree Azure surmounted by a martlet Gules*	Fig.17 p.17		

180 *Gules three lions passant guardant Or*	Fig.19	p.19
181 *[?] A fleur-de-lis Or*	Fig.19	p.19
182 *[?] A dragon couchant regardant*	Fig.19	p.19
183 *[?] A cross fleury ?Or/Argent voided*	Fig.20	p.20
184 *Azure a cross fleury Or voided Gules*	Fig.20	p.20
185 *Azure three chevrons [Or]*	Fig.20	p.20
186 *[Gules] three lions passant guardant Or within a bordure [Argent]*	Fig.20	p.20
187 *Or an owl passant guardant close Argent*	Fig.20	p.20
188 *Or a bird Sable armed Gules*	Fig.20	p.20
189 *[?] A cross engrailed Or*	Fig.20	p.20
190 *Gules a lion rampant ?Or/Argent*	Fig.20	p.20
191 *The letter 'R' from which spring three palm leaves ensigned with an open crown and two further leaves above*	Fig.20	p.20
192 *Azure a fleur-de-lis Or*	Fig.20	p.20
193 *A star of eleven points*	Fig.20	p.20
194 *A fess indented ?Or/Argent voided [?] between three ?Bezants/Plates*	Fig.20	p.20
195 *[?] A chevron ?Or/Argent between three roses ?Or/Argent*	Fig.20	p.20
196 *Gules three crowns Or*	Fig.20	p.20
197 *Gules three crowns Or*	Fig.21	p.21
198 *Gules three crowns [Or]*	Fig.21	p.21
199 *Azure three mitres (2, 1) labelled [Or]*	Fig.21	p.21
200 *Azure a cross patonce within a bordure Sable*	Fig.21	p.21
201 *Azure a griffin passant Argent*	Fig.21	p.21
202 *Azure a griffin passant Argent*	Fig.21	p.21
203 *Gules a lion rampant Or*	Fig.21	p.21
204 *Gules a lion rampant Or*	Fig.21	p.21
205 *Azure a lion rampant ?Or/Argent*	Fig.21	p.21
206 *Gules three lions passant guardant Or dimidiating Azure three ships hulls Or*	Fig.21	p.21
207 *Gules three lions passant guardant Or*	Fig.21	p.21
208 *[?] A lion passant guardant Argent*	Fig.21	p.21
209 *Gules a lion passant guardant ?Or/Argent*	Fig.21	p.21
210 *Gules a lion passant guardant ?Or/Argent*	Fig.21	p.21
211 *Gules a lion passant guardant Argent*	Fig.21	p.21
212 *Azure a lion passant ?guardant ?Or/Argent*	Fig.21	p.21
213 *Azure a lion passant ?Or/Argent*	Fig.21	p.21
214 *Gules a sexfoil ?Or/Argent*	Fig.21	p.21
215 *Gules three lions passant guardant Or*	Fig.21	p.21
216 *Gules a fess between six cross-crosslets (1,2,2,1) [Or]*	Fig.22	p.22
217 *Azure a cross patonce between five martlets to sinister Or*	Fig.22	p.22
218 *Azure a cross patonce between five martlets [Or]*	Fig.22	p.22
219 *[?] An eagle displayed ?Or/Argent*	Fig.22	p.22
220 *[?] A cross engrailed Or*	Fig.22	p.22
221 *Or a fess between two chevrons Gules*	Fig.22	p.22
222 *[?] A cross engrailed ?Or/Argent*	Fig.22	p.22
223 *Quarterly [Or] and [Gules] within a bordure Vair*	Fig.22	p.22
224 *Gules a head of ?Christ within an orle of ?triangles or ?mitres a cross lozengy in chief and in base ?Or/Argent*	Fig.23	p.24
225 *Argent a lion rampant Sable crowned Or*	Fig.23	p.24
226 *Quarterly 1 and 4 Azure semy-de-lis Or (France Ancient) 2 and 3 Gules three lions passant guardant Or (England)*	Fig.23	p.24
227 *Gules a fess between six crosses-crosslet (1,2,2,1) Or*	Fig.23	p.24
228 *Gules a lombardic letter 'M' Or*	Fig.23	p.24
229 *Gules a hearts head cabossed Or*	Fig.23	p.24
230 *Within a mount a tree*	Fig.23	p.24
231 *Azure three leaves co-joined in base Or*	Fig.23	p.24
232 *Quarterly Gules and Azure*	Fig.23	p.24
233 *Azure an ?escarbuncle of six arms fleury Or/Argent*	Fig.23	p.24
234 *Or a fleur-de-lis [?]*	Fig.23	p.24
235 *Azure an ?escarbuncle of six arms five with cinquefoil terminals that in base fleury ?Or/Argent*	Fig.23	p.24
236 *Or an eagle displayed Sable*	Fig.23	p.24
237 *An ?eagle displayed*	Fig.23	p.24
238 *Gules three lions passant guardant a label overall [?]*	Fig.24	p.25
239 *Or a chevron between three lions rampant Gules*	Fig.24	p.25
240 *?Or/Argent a griffin segreant Azure armed Gules*	Fig.24	p.25
241 *[?] A pelican in piety Or*	Fig.24	p.25
242 *Gules three lions passant guardant Or*	Fig.24	p.25
243 *Or a three-branched tree surmounted by a lion couchant guardant Argent*	Fig.24	p.25
244 *Azure a fleur-de-lis [Or]*	Fig.24	p.25
245 *Gules a triple-towered castle Or*	Fig.24	p.25
246 *?Or/Argent a quatrefoil Gules*	Fig.24	p.25

Appendix 4: Glossary

The glossary provided here is limited to the heraldic terminology employed in this volume and is in no sense exhaustive. It is largely based upon that provided by John Brooke-Little in *An Heraldic Alphabet* (1985). A reliable guide to the correct application of these terms can be found in *Boutell's Heraldry* (Brooke-Little 1973). The various types of cross listed here are illustrated in Figure 26.

Addorsed	Placed back to back
Affronty	Facing the observer
Annulet	A ring
Argent	Silver
Armed	Describes the offensive and defensive parts of a creatures anatomy when of a different tincture from that of the body
Armory	(i)The study of arms (ii)A dictionary of arms listed under surnames
Arms	The shield and what is borne upon it
Attired	Word used to describe antlers
Azure	Blue
Bar	An ordinary, narrower than the fess, but which traverses the shield horizontally in a similar manner
Barry	Divided barwise into an even number of divisions
Base	The foot of the shield
Bend	An ordinary consisting of a broad band extending from dexter chief to sinister base
Bend sinister	A bend reversed, that is, running from sinister chief to dexter base
Bendy	A shield divided bendwise into an even number of divisions
Bezant	A gold roundel
Bezanty	Semy of bezants
Billet	An oblong rectangle
Billety	Semy of billets
Blazon	To blazon arms is to describe them in correct armorial terminology so that they can be correctly rendered from the verbal description, which is itself called a blazon
Bordure	A border running round and up to the edge of the shield
Bottony	See Fig.26
Braced	Interlaced, especially of chevrons
Cabossed	Applied to an animal's head when shown affronty and cut off cleanly so that no part of the neck is shown
Cadency	The practice of making the arms of every cadet of a family different to those of the head
Canton	A square portion of the shield, smaller than the quarter, in the dexter chief
Catherine wheel	A wheel usually having eight spokes, each one ending in a curved spike
Charge	Anything borne on a shield or on another charge
Checky	Term applied to a field or charge divided into small squares of two alternate tinctures
Chevron	An ordinary issuing from the base of the shield shaped like an inverted V
Chevronny	Divided into an even number of divisions chevron-wise
Chief	An ordinary which consists of the top third of the shield
Cinquefoil	A figure having five petals or leaves
Colours	The colours used in armory are Blue (*Azure*), Red (*Gules*), Black (*Sable*), Green (*Vert*) and Purple (*Purpure*). There are a number of others not listed here as they are rarely used
Compony	Used when an ordinary is made up of small squares of a metal and a colour in one row alternately
Combattant	Used of two beasts when shown rampant and face to face
Confronted	Used of two beasts facing one another
Cotised	Term applied to a bend when shown flanked by a bendlet on each side
Couchant	Describes a beast when lying down with head up
Counter-changed	A devise by which the shield is divided by a partition line, the colours or metals on one side of it being reversed on the other side
Couped	Cut off cleanly
Courant	Running at full speed
Crescent	A half-moon with the horns pointing upwards
Cross	An ordinary consisting of a broad cross throughout (for the various forms of cross see Fig.26)
Cross of Toulouse	See Fig.26
Crosslet	See Fig.26
Crusily	Semy of cross-crosslets

	
Dancetty	A line of partition similar to indented but showing only three indentations
Demi	A prefix applied to any charge which has been bisected and of which only one half is shown
Dexter	The right-hand side of the shield from the point of view of the bearer
Diapered	Patterned
Difference, Marks of	Alterations to arms to distinguish the male members of the family one from the other
Displayed	Used of a bird whose wings are outspread, the tips pointing upwards
Dormant	Sleeping
Double-headed	With two heads, Usually one head looks to the dexter and the other to the sinister
Embattled	Crenellated
Emblazon	To depict armorial bearings in colour
Enfile	To surround or encircle
Engrailed	A line of partition by which ordinaries are diversified, composed of semicircles the teeth or points of which enter the field (the terms *Engrailed* and *Indented* were originally synonymous)
Ensigned	Said of a charge which has a crown placed above it
Erased	Torn off roughly so as to leave a jagged edge
Erect	A term applied to a charge shown upright when it would not normally be so depicted
Ermine	One of the two principle furs used in heraldry. It consists of black ermine tails shown on a white field
Escallop	The scallop shell
Escarbuncle	Ornamental spokes radiating from a central boss, probably derived from the decorative iron strengthening on a shield
Escutcheon	A shield
Estoile	A star of (usually) six points with wavy rays
Fess	An ordinary consisting of a broad horizontal band drawn across the centre of the shield
Fermaux	A buckle
Field	The surface of the shield on which the charges are placed. It may be plain, patterned or divided
Fimbriated	Edged
Fitchy	Pointed at the foot
Flaunches	Two arcs of circles on either side of the shield
Fleur-de-lis	A stylised form of lily
Fleury	See Fig.26
Fret	A mascule interlaced by a bendlet and a bendlet sinister
Fretty	Bendlets and bendlets sinister interlaced to form a lozengy pattern like a net or trellis
Fusil	A long narrow lozenge
Fusilly	Similar to lozengy but using fusils
Griffin	A monster which has the hind parts of a lion and the head, breast, claws and wings of an eagle
Guardant	With the face looking outwards
Gules	Red
Gyron	Half a quarter divided by a diagonal line
Gyronny	Divided into wedge-shaped sections by three or more intersecting lines
Haurient	Applied to a fish when erect with head upwards
Impale	To divide the shield per pale and place one coat on the dexter, another on the sinister side
Indented	Notched like dancetty but with much smaller indentations (the terms *Engrailed* and *Indented* were originally synonymous)
Inescutcheon	When a shield or escutcheon is borne as a charge
Issuant	Issuing or proceeding from
Jelloped	Wattled
Label	A horizontal band from which depend three vertical pieces. Usually a mark of difference for an eldest son
Lozenge	A charge shaped like a diamond
Lozengy	Divided bendy and bendy sinister to give a pattern of lozenges
Maculate	Spotted
Martlet	A swift or house-martin which has no legs, only tufts of feathers
Mascule	A voided lozenge
Maunch	An ancient sleeve severed at the shoulder
Metals	The metals used in heraldry are gold (Or) and silver (Argent)
Mitre	A bishops hat
Monster	Any fabulous creature
Moline	See Fig.26
Mount	A grassy hillock
Mullet	A star, or spur-rowel, usually of five points
Naiant	Used to describe a fish swimming horizontally

Figure 26 Types of cross represented in the Ordinary:
a) Moline, b) Recercelee, c) Patonce, d) Fleury,
e) Bottony, f) Toulouse, g) Potent, h) Crosslet, i) Patee,
j) Cross (of St George *etc.*)

Nebuly	A waisted wavy line of partition
Or	Gold
Ordinary	A dictionary in which arms are listed alphabetically by the charges they contain. Also the term employed for certain basic geometrical charges
Orle	Like a bordure but not reaching the edges of the shield
Over all	Used of a charge which is superimposed over several other charges
Pale	An ordinary consisting of a broad vertical band drawn down the centre of the shield
Pall	A figure which resembles the shape of the ecclesiastical vestment, or Y
Paly	Divided palewise into an even number of divisions
Party	Divided
Passant	Used to describe beasts who are walking along with the dexter fore-paw raised
Patonce	See Fig.26
Patee	See Fig.26
Peacock	If blazoned 'in his pride' then shown affronty with tail displayed
Pelican	Usually shown with wings raised pecking her breast, or 'vulning herself'. If blazoned 'in her piety' then shown standing on her nest feeding her young with her blood
Pheon	An arrowhead, point downward, with barbs engrailed on the inner edge
Pierced	A charge pierced through with a hole exposing the colour of the field
Pile	An ordinary consisting of a triangular wedge issuing from the top of the shield
Plate	A term applied to a roundel when it is silver
Potent	An ancient term for crutch. A cross potent has crutched ends (see Fig.26). The name is also given to a fur (really hair) with the cups drawn like crutch ends
Proper	A term used when a charge is shown in its natural colour
Purpure	Purple
Quarter	A sub-ordinary which occupies one quarter of the shield
Quarterly	Divided into rectangular divisions by lines palewise and fesswise, and described as quarterly of as many pieces as are formed by the dividing lines
Quatrefoil	A four-leaved figure
Queue forchee	A forked tail
Rampant	A beast with its left hind-leg shown on the ground whilst the other legs wave fiercely in the air
Recercelee	See Fig.26
Reguardant	Looking back over the shoulder
Respectant	Two creatures facing each other

Roundel	A disc, the name of which varies according to its tincture
Sable	Black
Salient	Used to describe beasts when springing or leaping
Saltire	An ordinary consisting of a cross placed diagonally on a shield
Segreant	Used as a synonym for rampant when describing a griffin in this posture
Sejant	Used to describe beasts in the sitting position
Semy	Strewn or powdered with small charges
Shield	The principle vehicle for the display of arms
Sinister	The left-hand side of the shield from the point of view of the bearer
Sixfoil	A six-leaved figure
Slipped	Used of flowers and leaves which have stalks
Statant	Used of animals when standing with all four feet on the ground
Supporters	Figures placed on either side of the shield to support it
Tinctures	This term refers to all heraldic colours, metals and furs
Trefoil	A three-leaved figure
Tressure	A diminutive of the orle
Trippant	Used in place of *passant* when describing beasts of the deer variety in this position
Vair	One of the two principal furs used in heraldry, consisting of small animals' skins joined together head to tail
Vert	Green
Voided	A term meaning that the middle of the charge has been cut out, allowing the field or another tincture to show through
Vol	Two wings cojoined at the base with tips pointing upwards
Volant	A bird flying
Water-bouget	A yoke supporting two water-bags
Wyvern	A monster which resembles a dragon in every respect except that it has no hind-quarters, its rear ending in a barbed tail

Bibliography

Adam-Even, P. 1954 — 'The valence enamel' *The Coat of Arms* III, 45–6

Ailes, A. 1982 — *The Origins of the Royal Arms of England; Their Development to 1199* (Reading)

Ailes, A. 1990 — 'Heraldry in twelfth-century England: the evidence' in Williams, D. (Ed.) *England in the Twelfth Century: Proceedings of the 1988 Harlaxton Symposium* (Woodbridge) 1–16

Ailes, A. 1992 — 'The knight, heraldry and armour: the role of recognition and the origins of heraldry' in Harper-Bill, C. and Harvey, R. (Eds) *Medieval Knighthood IV; Papers from the fifth Strawberry Hill Conference 1990* (London)

Alexander, J. and Binski, P. (Eds) 1987 — *Age of Chivalry: Art in Plantagenet England 1200–1400* (London)

Archaeological Journal — 'Proceedings at the meetings of the Archaeological Institute, antiquities and works of art exhibited by Mr Fitch', *Archaeological Journal* 12, 89

Archibald, M. 1984 — 'Coins' in Zarnecki, G., Holt, J. and Holland, T. (Eds) *English Romanesque Art, 1066–1200* (London) 320–341

Armstrong, E.C.R. 1912 — 'A note on four armorial pendants in the Academy's collection' *Proceedings of the Royal Irish Academy* 30, 191–4 and plates 10–11

Ashley, S. 1999a — *Medieval Armorial Horse Furniture in Norfolk* (Dissertation for the Diploma of the Heraldry Society)

Ashley, S. 1999b — 'The use of lions combatant on late twelfth/early thirteenth-century horse furniture' *The Coat of Arms* New Series 13, 125–6

Ashley, S. 2001 — 'Knights, stars and comets: decoration on twelfth century shields and harness', *The Coat of Arms* New Series 14, 121–9

Ashley, S. forthcoming a — 'Shield-shaped mount' in Emery, P.A. *Norwich Greyfriars: Excavations at the former Mann Egerton Site, Prince of Wales Road, Norwich 1992–1995*

Ashley, S. forthcoming b — 'Iron horse harness pendant' in Shepherd-Popescu, E. *Excavations in and around the South Bailey of Norwich Castle, 1987–1991* East Anglian Archaeology

Austin, D. 1989 — *The Deserted Medieval Villiage of Thrislington, County Durham, Excavations 1973–4* Society for Medieval Archaeology Monograph 12 (Lincoln)

Barber, R. 1978 — *The Devils Crown; A History of Henry II and his Sons* (London)

Bates, D. 1982 — *Normandy before 1066* (London)

Bellew, Sir G. 1957 — 'Escallops in armory' in Cox, I. (Ed) *The Scallop* (London), 89–104

Beresford, G. 1975 — *The Medieval Clay-land Village: Excavations at Goltho and Barton Blount* The Society for Medieval Archaeology monograph 6 (London)

Blomefield, F. 1805–10 — *An Essay Towards a Topographical History of the County of Norfolk,* continued by C. Parkin (London)

Blake, W. J. 1952 — 'Norfolk manorial lords in 1316' *Norfolk Archaeology* 30, 234–86

Brault, G.J. 1972 (second edition 1997) — *Early Blazon; Heraldic Terminology in the Twelfth and Thirteenth Centuries with special reference to Arthurian Heraldry* (Woodbridge)

Brault, G. J. 1997 — 'The Rolls of Arms of Edward I (1272–1307)' Vols I and II, *Aspilogia*; Vol. 3 (London)

British Museum 1907 — *A Guide to the Medieval Room* (London)

Brooke-Little, J.P. (Ed.) 1973 — *Boutell's Heraldry* (London)

Brooke-Little, J.P. 1985 — *An Heraldic Alphabet* (London)

Brown, P. (Ed.) 1984 — *Domesday Book: Norfolk* (2 Parts) (Chichester)

Burke, B. 1883 — *A Genealogical History of the Dormant, Abeyant, Forfeited, and Extinct Peerages of the British Empire* (London)

Burlington Fine Arts Club 1916 — *Catalogue of a Collection of Objects of British Heraldic Art to the end of the Tudor Period* (London)

Butler, L. 1989 — 'Objects of metal, bone and clay' in Butler, L., and Wade-Martins, P. *The Deserted Medieval Village of Thuxton, Norfolk* East Anglian Archaeology 46, 36–40

Campbell, B. M. S. 1986 — 'The complexity of manorial structure in medieval Norfolk: a case study' in *Norfolk Archaeology* 34, 225–61

Campbell, B. M. S. 1993 — 'Medieval manorial structure' in Wade-Martins, P. (Ed.) *An Historical Atlas of Norfolk* (Norwich) 52–3

Campbell, M. 1987 — 'Metalwork in England c.1200–1400' in Alexander, J. and Binski, P. (Eds) *Age of Chivalry: Art in Plantagenet England 1200–1400* (London), 162–8

Campbell, M. 1990 — 'The anarchist and forger Louis Marcy' in Jones, M (Ed.) *Fake? The art of deception* (London) 185–7

Campbell, M. 1991 — 'Gold, silver and precious stones' in Blair, J. and Ramsay, N. (Eds) *English Medieval Industries; Craftsmen, Techniques, Products* (London) 107–66

Cherry, J. 1991 — 'Harness pendants' in Saunders, P. and Saunders, E. (Eds) *Salisbury Museum Medieval Catalogue*; Part 1 (Salisbury), 17–28

Chesshyre, H. and Woodcock, T. (Eds) 1992 — *Dictionary of British Arms; Medieval Ordinary* Vol.1 (London)

City Museum and Art Gallery, Birmingham 1936 — *Catalogue of an Heraldic Exhibition at the City Museum and Art Gallery, Birmingham* (Birmingham)

Clinch, G. 1910	'Armorial Pendant found at Mitcham' *Surrey Archaeological Collections* 23, 212	Friar, S. 1987 (Ed)	*A New Dictionary of Heraldry* (London)
Coad, J.G., and Streeten, A.D.F. 1982	'Excavations at Castle Acre Castle, Norfolk, 1972–77: country house and castle of the Norman earls of Surrey' *Archaeological Journal* 139 (London), 138–301	Garmonsway, G.N. 1953 (Trans)	*The Anglo-Saxon Chronicle* (London)
		Goodall, A.R. 1992	'Non-ferrous metal objects' in Dallas, C. *Excavations in Thetford by B.K. Davidson between 1964 and 1970* East Anglian Archaeology 62, 95–6
Coss, P. 1991	*Lordship, knighthood and locality: a study in English society c.1180–c.1280* (Cambridge)	Goodall, I.H. 1980	'Objects of copper alloy' in Wade-Martins, P. 'Excavations in North Elmham Park 1967–1972' *East Anglian Archaeology* 9, Vol. II, 499–505
Courtney, P. 1994	'Copper alloy objects' in Manley, J. 'Excavations at Caergwrle Castle, Clwyd, North Wales: 1988–1990' *Medieval Archaeology* 38, 83–133	Goodall, J.A. 1998	'Simon de Montfort (*c.*1170–1218) and an unusual marshalling of arms' *Antiquaries Journal* 78, 433–9
Crouch, D. 1992	*The Image of Aristocracy in Britain 1000–1300* (London)		
Davies, T.R. 1979	'As it was in the beginning' *The Coat of Arms* New Series 3, 114–24	Goodall, J., and Woodcock, T. 1991	'Armorial and other pendants, studs and ornaments' *Antiquaries Journal* 71, 239–47
Davies, T.R. 1984	'Diaper, paillé and papelonné' *The Coat of Arms* New Series 6, 2–9	Gordon Childe, V. 1938	'Doonmore, a castle mound near Fair Head, Co. Antrim' *Ulster Journal of Archaeology* Third Series 1, 122–135
Deér, J. 1959	*The Dynastic Porphory Tombs of the Norman Period in Sicily,* Dumbarton Oaks Sudies Five (Cambridge, Mass.)	Granger-Taylor, H. 1994	'Silk from the tomb of Edward the Confessor' in Buckton, D. *Byzantium; Treasures of Byzantine Art and Culture from British Collections* 151–3
Denholm-Young, N. 1965	*History and Heraldry 1254 to 1310: A Study of the Historical Value of the Rolls of Arms,* (Oxford)	Graham-Campbell, J. 1992	'Anglo-Scandinavian equestrian equipment in eleventh-century England' in Chibnall, M. (Ed) *Anglo-Norman Studies* 14, 77–89
Denholm-Young, N. 1969	*The Country Gentry in the Fourteenth Century with special reference to the Heraldic Rolls of Arms* (Oxford)	Griffiths, N. 1986a	'Medieval pendants from Edington and Sharcott' *Wiltshire Archaeological Magazine* 80, 221–3
Digby, G.W., and Hefford, W. 1971	*The Devonshire Hunting Tapestries* (London)	Griffiths, N. 1986b	*Horse Harness Pendants,* Finds Research Group 700–1700, Datasheet 5 (Coventry)
D'Onofrio, M. (Ed.) 1994	*I Normanni; Popolo d'Europa 1030–1200* (Venice)	Griffiths, N. 1989	*Shield-shaped Mounts,* Finds Research Group 700–1700, Datasheet 12 (Oxford)
Douglas, D.C. 1969	*William The Conqueror; The Norman Impact upon England* (London)	Griffiths, N. 1995	'Harness pendants and associated fittings' in Clarke, J., *The Medieval Horse and its Equipment* (London), 61–71
Duby, G. 1977	*The Chivalrous Society* (London)		
Dunning. G.C. 1965	'Heraldic and decorated metalwork and other finds from Rievaulx Abbey, Yorkshire' *Antiquaries Journal* 45, 53–63	Grinder-Hansen, P. 1992	'Aquamanile' in *From Viking to Crusader: Scandinavia and Europe 800–1200* (Uddevalla) 353
East, K. 1986	'A lead model and a rediscovered sword, both with gripping beast decoration' *Medieval Archaeology* 30, 1–7 and plates I and II	Grinsell, L., Rahtz, P., and Price Williams, D. 1974	*The Preparation of Archaeological Reports* (London)
Egan, G. 1991a	'Mounts' in Egan, G. and Pritchard, F. *Dress Accessories c.1150–c.1450* Medieval Finds from Excavations in London: 3 (London) 162–243	Gurney, D. 1997	'A note on the distribution of metal-detecting in Norfolk' *Norfolk Archaeology* 42, 528–32
Egan, G. 1991b	'Combinations of diverse strap fittings, and possible ensuite items' in Egan, G. and Pritchard, F. *Dress Accessories c.1150–c.1450* Medieval Finds from Excavations in London: 3 (London) 244–6	Gurney, D. (Ed.) 1997	'Archaeological finds in Norfolk 1995' *Norfolk Archaeology* 42, 395
		Harvey, P.D.A., and McGuinness, A. 1996	*A Guide to British Medieval Seals* (London)
Egan, G. 1996	'The archaeological evidence for metalworking in London *c.*1050 AD–*c.*1700 AD' in *Journal of the Historical Metallurgy Society* 30 (2), 83–94	Harvey, Y. 1975	'The bronze' in Platt, C. and Coleman-Smith, R., *Excavations in Medieval Southampton 1953–1969 Vol.2 The Finds* (Leicester), 254–68
Ellis, R.H. 1978 and 1981	*Catalogue of Seals in the Public Record Office: Personal Seals* Vols.1 and 2 (London)	Hemp, W.J. 1936	'Four heraldic pendants and three roundels' *Antiquaries Journal* 26, 291–4
Foot, M. 1984	'Bindings' in Zarnecki, G., Holt, J. and Holland, T. (Eds) *English Romanesque Art 1066–1200* (London) 342–9	Heslop, T.A. 1984	'Seals' in Zarnecki, G., Holt, J. and Holland, T. (Eds) *English Romanesque Art, 1066–1200* (London) 298–319
Fox-Davies, A.C. 1950	*A Complete Guide to Heraldry* (London)	Heslop, T.A. forthcoming	'Courtliness and the culture of consumption'
Freeman, E.A. 1870–9	*A History of the Norman Conquest of England,* 5 vols and index (Oxford)	Hicks, C. 1993	*Animals in Early Medieval Art* (Edinburgh)

Higham, R., and Barker, P. 1992 — *Timber Castles* (London)

Hinkle, W.M. 1991 — *The Fleurs de Lis of the Kings of France 1285–1488* (Southern Illinois)

Hinton, D.A. 1999 — '"Closing" and the Later Middle Ages' *Medieval Archaeology* 43, 172–82

Holyoake, C.J. 1954 — 'The Arms of William de Valence and the Reggio Emilia Enamel' *The Coat of Arms* III, 87–9

Hurst, J.G. 1962 — 'The kitchen area of Northolt manor, Middlesex' *Medieval Archaeology* 5, 211–99

Jenkins, T.B. 1958–9 — 'Medieval armorial pendants' *The Coat of Arms* V, 101–2

Jones, M., and Walker, S. (Eds.) 1994 — 'Private Indentures for Life Service in Peace and War 1278–1476' *Camden Miscellany* 32, (Camden Fifth Series; vol.3), (London)

Kauffmann, C.M. 1975 — *Romanesque Manuscripts 1066–1190,* A Survey of Manuscripts Illuminated in the British Isles, 3 (London)

Laking, Sir G.F. Bart. 1922 — *A Record of European Armour and Arms Through Seven Centuries, Volume 6: Bows, Daggers, Gauntlets, Horse Armour and Shields* (London)

La Niece, S. 1993 — 'Silvering' in La Niece, S. and Craddock, P. (Eds) *Metal Plating and Patination* (London) 201–10

Latham, R.E. 1965 — *Revised Latin Word-List from British and Irish sources* (London) 298

Le Patourel, H.E.J. and Roberts, B.K. 1978 — 'The significance of moated sites' in Aberg, F.A. *Medieval Moated Sites* (London), 46–55

London, H. S. 1949a — 'The ghost or shadow as a charge in heraldry' *Archaeologia* 93, 125–49

London, H. S. 1949b — 'Two fourteenth-century pendants with the arms of Trublevile' *Antiquaries Journal* 29, 204–6

London, H. S. 1958 — 'Pattee, patonce and formee' *The Coat of Arms* IV, 358–64

London, H.S. and Tremlett, T.D. 1967 — 'Rolls of Arms of Henry III' *Aspilogia*; Vol. 2 (London)

Margeson, S. 1979 — 'Medieval horse-harness fittings from Norfolk' *Norfolk Archaeology* 37, 227–8

Margeson, S. 1993 — *Norwich Households: The Medieval and Post-Medieval Finds from Norwich Survey Excavations 1971–1978* East Anglian Archaeology 58 (Norwich)

Margeson, S. 1994a — 'Castles' in Margeson, S., Seillier, F. and Rogerson, A. *The Normans in Norfolk* (Norwich) 22–39

Margeson, S. 1994b — 'Monasteries and churches' in Margeson, S., Seillier, F. and Rogerson, A. *The Normans in Norfolk* (Norwich) 40–69

Marks, R. and Payne, A. 1978 — *British Heraldry from its Origins to c.1800* (London)

Martín Ansón, M.L. 1994 — *Catàleg de xapes de guarniment* Fons del Museu Frederic Marès/2 (Barcelona)

Mitchiner, M. 1988 — *Jettons, medalets and tokens* Vol.1 The Medieval Period and Nuremberg (London)

Murray, H.K. and Murray, J.C. 1993 — 'Excavations at Rattray, Aberdeenshire. A Scottish deserted burgh' *Medieval Archaeology* 37, 109–218

Nelson, P. 1916 — 'Equestrian aquamaniles' *Transactions of the Historical Society of Lancashire and Cheshire* 67, 78–85

Nelson, P. 1940 — 'A medieval armorial brooch' *Antiquaries Journal* 20, 387

Neubecker, O. and Brooke-Little, J.P. 1997 — *Heraldry: Sources, Symbols and Meaning* (London)

Newman, J. and Pevsner, N. 1972 — *The Buildings of England: Dorset* (Harmondsworth)

Nicolle, D. 1999 — *The Crusades* (Oxford)

Orderic Vitalis (Ed. and Trans. Chibnall, M.) 1969–80 — *Ecclesiastical History* (6 vols) (Oxford)

Palizzolo Gravina, V., Barone Di Ramione 1871–5 — *Il Blasone in Sicilia; Dizionario Storico-Araldico della Sicilia* (Palermo)

Panofsky, E. 1953 — *Early Netherlandish Painting,* 2 vols (Cambridge, Mass.)

Papworth, J.W. 1874 (reprinted 1985) — *Ordinary of British Armorials* (London)

Pastoureau, M. 1996 — 'The use of heraldry in Limousin enamels' in *Enamels of Limoges 1100–1350* Metropolitan Museum of Art Exhibition Catalogue (New York), 339–42

Payne, A. 1987 — 'Medieval heraldry' in Alexander, J. and Binski, P. (Eds) *Age of Chivalry: Art in Plantagenet England 1200–1400* (London), 55–9

Pevsner, N. and Wilson, B. 1998 — *The Buildings of England* Norfolk 1: Norwich and North-East (London)

Platts, B. 1980 — *The Origins of Heraldry* (London)

Prideaux, W. de C. 1911 — 'Notes on medieval enamelled armorial horse trappings with especial reference to a Weymouth find' *Proceedings of the Dorset Field Club* 32, 226–38

Rahtz, P.A. 1969 — *Excavations at King John's Hunting Lodge, Writtle, Essex 1955–57* Society for Medieval Archaeology Monograph 3 (London)

Riley-Smith, J. 1995 — 'The state of mind of crusaders to the east, 1095–1300' in Riley-Smith, J. (Ed) *The Oxford Illustrated History of the Crusades* (Oxford), 66–90

Roach-Smith, C. 1868 — 'Researches and discoveries' *Collectanea Antiqua* 6, 278–9

Rogerson, A. 1993 — 'Moated sites' in Wade-Martins, P. (Ed.) *An Historical Atlas of Norfolk* 66–7

Rowley, T. 1999 — *The Normans* (Stroud)

Runciman, S. 1998 — *A History of the Crusades; volume ii, The Kingdom of Jerusalem and the Frankish East 1100–1187* (Cambridge)

Rye, W. 1909 — *Catalogue of Antiquities in the Norwich Castle Museum* (Norwich)

Rye, W. 1913 — *Norfolk Families* (Norwich)

Rye, W. 1917 — *A List of Coat Armour used in Norfolk Before the date of the first Herald's Visitation of 1563* (Norwich)

Scott, Sir W. 1819 (reprinted 1986) — *Ivanhoe* (London), 18

Shepherd-Popescu, E. forthcoming — *Excavations in and around the South Bailey of Norwich Castle, 1987–1991* East Anglian Archaeology

Shortt, H. de S. 1951 — 'An enamelled roundel from Wiltshire' *Antiquaries Journal* 31, 72–4

Smith, C.E.J. 1990 — 'The livery collar' *The Coat of Arms* New Series 8, 238–53

Spencer, B. 1980 — *Medieval Pilgrim Badges from Norfolk* (Norwich)

Stratford, N. 1984 — 'Metalwork' in Zarnecki, G., Holt, J. and Holland, T. (Eds) *English Romanesque Art 1066–1200* (London), 232–95

Taburet-Delahaye, E. 1996a — 'Coffret of Abbot Boniface' in *Enamels of Limoges 1100–1350* Metropolitan Museum of Art Exhibition Catalogue (New York), 78–82

Taburet-Delahaye, E. 1996b — 'Carrand medallions' in *Enamels of Limoges 1100–1350* Metropolitan Museum of Art Exhibition Catalogue (New York), 83–86

Taburet-Delahaye, E. 1996c — 'Effigy of Geoffrey Plantagenet' in *Enamels of Limoges 1100–1350* Metropolitan Museum of Art Exhibition Catalogue (New York), 98–101

Taylor, A. 1985 — 'Prehistoric, Roman, Saxon and medieval artefacts from the southern fen edge, Cambridgeshire' *Proceedings of the Cambridge Antiquarian Society* 74, 1–52

Thordeman, B, with Nörlund, P. and Ingelmark, M.B. 1939 — *Armour from the Battle of Wisby 1361* Vols I and II (Stockholm)

Tudor-Craig, P. 1973 — *Richard III* National Portrait Gallery Exhibition Catalogue (London)

Wade-Martins, P. 1993 — *An Historical Atlas of Norfolk* (Norwich)

Wagner, A.R. 1954 — 'Heraldic Designs—No. 2' *The Coat of Arms* III, 4–5

Wagner, A.R. 1956 — *Heralds and Heraldry of the Middle Ages* (Oxford)

Wagner, A.R. 1978 — *Heralds and Ancestors* (London)

Wamers, E. 1987 — 'A 10th-century Metal Ornament from Mainz, West Germany' *Medieval Archaeology* 31, 105–9

Ward-Perkins, J.B. 1940 — *London Museum Medieval Catalogue* (London) (reprinted 1954 and 1967)

Ward-Perkins, J.B. 1949 — 'A medieval harness-mount at Termoli' *Antiquaries Journal* 29, 1–7 and plates I and II

Wilmott, T. 1982 — 'A medieval armorial brooch or pendant from Baynard Castle' *Transactions of the London and Middlesex Archaeological Society* 33, 299–302

Wilson, D.M. 1985 — *The Bayeux Tapestry* (London)

Woodcock, T., Grant, J. and Graham, I. 1996 — *Dictionary of British Arms: Medieval Ordinary* Vol.2 (London)

Zarnecki, G., Holt, J. and Holland, T. (Eds) 1984 — *English Romanesque Art, 1066–1200* (London)

Index

Illustrations are denoted by page numbers in *italics*. Places are in Norfolk unless otherwise indicated. Blazons are in *italics*.

Adrano (Sicily), sculpture, *29*
Agilon, arms of, 47, 53
Alburgh, 51
Alexander II, 8
Alnwick, Bishop of, arms of, 43–4, 53
aquamanile, 30, *31*
architectural motifs, origins, 28–9
Artois, Blanche d', Countess of Champagne, 45
Ashbocking (Suffolk), 37
Ashill, 34, 51, 52
Ashmanhaugh, 50
Ashpole (Aspal; Aspale), Sir John, arms of, 42, 53
Ashwellthorpe, 37, 39, 43
Aslacton, 36
Aspal (Aspale) *see* Ashpole
Attleborough, 41, 49
Aylmerton, 5, 45
Aylsham, 45

Bacton, 5, 43, 44
badges, armorial, 18, 23, *26*
Badlesmere (Kent), 46
Badlesmere, Bartholomew de, arms of, 8, 46, 53
Banham, 44
bar, *11*, *14*, 34, 59
Barre, de, arms of, 46, 53
barry, 7, 16, *18*, 28, 34, 59
barry/paly, *14*, 16, *18*, 34, 61
Bawdeswell, 40, 43
Bayeux Tapestry, 7, 27, 29
Baynard, Robert, arms of, 8, 46, 53
Beachamwell, 49
beast, 28, 29, 34–9; *see also* bull; dog; hart and in base; lion; monster
Beauchamp, Earls of Warwick
 arms of, 46, 53
 Walter de, 46, 53
 William de, 46
Beeston with Bittering, 39, 46
Beeston Regis, 35, 37, 40
Beetley, 49, 51
Beler, arms of, 37, 53
Belton, 43
bend, *15*, 40, 59
Berton by Swathling (Hants), 48
Besthorpe, 26, 37
bezanty/platty, *15*, 40, 59
Bigod, Roger le, Earl of Norfolk, arms of, 43, 53
billet, 28, 29, 59
Bingham (Notts), 46
Bingham, Richard de, arms of, 8, 46, 53
Binham, 35, 36, 40, 49
Bintree, 51
Bircham, 40, 50
bird, 16, 20, 29, 40, 41; *see also* crane; eagle; owl; peacock; pelican; raven; swan
Bixley, 44
Blachington (Sussex), 48
Blackborough Priory, effigy, 4
Blakeney, 48
Blaxhall (Suffolk), 37
blazons, listed, 55–8
Blo Norton, 40
Bluet, arms of, 40, 53
Bohemond I, Prince of Antioch, 28
Bohemond III, Prince of Antioch, 28
Bohun, Earls of Hereford and Essex
 arms of, 8, 16, 30, 33, 39–40, 53
 Humphrey de, 33
Booton, 42, 46
Boughton *see* Browton
boule, 28
Boun, John de, arms of, 43, 53

Bradenham, 34, 41, 45, 47
Bradwell, 34
Brampton, 34
Brandeston (Suffolk), 37
Braose (Brewes), arms of, 37, 53
Brettenham, 38
Brewes *see* Braose
Brews, Thomas de, arms of, 36, 53
Brinton, 42
Brocburn, arms of, 41, 53
Broome, 36, 39
Browton (Boughton), arms of, 48, 53
bull, *9*, 34
Bunwell, 39
Burdet
 Nicholas, arms of, 46, 53
 William, 46
Bures, William of, Prince of Galilee, 28
Burgh Castle, 49
Burnham Norton, 38
Burnham Thorpe, 47
Bury St Edmunds, arms of, 45, 53
Buxton with Lammas, 36, 37, 39, 50
Bylaugh, 34, 35, 50

Caistor St Edmund, 36, 48
Carbrooke, 43
Carleton (Lincs), 40
Castille
 arms of, 18, 41, 47, 53
 Blanche of, 18, 47, 53
castle, *19*, *25*, 41
Castle Acre, 5–6, 26
Castle Rising, 36
Cawston, 36, 51
Champagne
 Count of *see* Crouchback, Edmund
 Henry and Blanche, arms of, 45, 53
Chaucer, 16
checky, 5, *6*, *13*, *15*, 27, 41, 59
checky and label, *15*, 41, 59, 60
chevron, *10*–*11*, *15*–*16*, *20*, *25*, 28, 29, 42, 59
chief, *10*, *13*, *15*, *17*, 42, 59
Chilham Castle (Kent), 46
chip carving, 28
Christ, head of, 23, *24*, 48
Clare, Earls of Gloucester and Hereford, arms of, 30, 42, 53
Clenchwarton, 36
Clifford, Robert and Roger de, arms of, 46, 53
Clipston (Notts), 46
cloth, imported, 28, 29
Colevile (Colville; Colvyle), Sir John, arms of, 36, 53
Colkirk, 46
Colney, 38
combs, *12*, 43
Congham, 35, 38, 39, 41, 46
cope, *26*
Costessey, 5, 40, 41, 47, 50
Covington (Dumf), 40
crane, *18*, *29*, 40
Cranemere, arms of, 40, 53
Cranworth, 38, 43, 49
cross, *9*, *10*, *14*, 43
 on a, *10*, *13*, 44–5
 between, *4*, *22*, 44
 and canton, *15*, 44
 and chief, *14*, 45
 engrailed, *6*, *13*, *20*, *22*, 43
 fleury, *16*, 43–4
 impaling, *17*, 45
 indented, *42*, 44
 patee, 44
 patonce, *14*, 44
 potent, *15*, 16, *17*, 44
 recercelee, *11*, 44

67

Toulouse, 18, *19*, *20*, 44, 59
types, 59, *61*
within, *21*, 45
Crouchback, Edmund, Earl of Lancaster, Count of Champagne, arms of, 45
crown, *11*, *20*, *21*, 23, 45
Croxton, 23, 41
Crusades, 27–8
curb bits, 4

Dacre, 26
Darcy
 arms of, 8, 47, 53
 Norman, 47
 Philip, 47
 Thomas (2), 47
decline, 31–2
Delamare, arms of, 37, 53
Dendermonde (France), font, 27
Deopham, 40, 45
Derham, arms of, 48, 53
Diss, 46
distribution of finds, 2, 30
dog, 34
dragon, 18, *19*, 49

eagle, *15*, *16*, *22*, 23, *24*, *26*, 40–1
East Dereham, 41
East Harling, 44
East Rudham, 26, 51
East Tuddenham, 36, 37
East Walton, 46
Eccleshall, arms of, 39, 53
Eccleswall (Heref), 40
Edmund, St, arms of, 45, 54
Edward, St, arms of, 44, 54
Edward the Confessor, 29
Edward I, 30, 38, 39
Edward II, 23, 38, 39
Edward III, 38, 39
elaborate sets, *8*, 23, *25*
Ellingham, 39
Ely, Bishop of, arms of, 23, 45, 53
Emneth, 34, 42, 52
enamelling, 2, 29–30
England, arms of, 8–9, 16, 38–9, 50, 53
England and France, arms of, 9, 35, 36, 37, 53
English Apocalypse, 1, *33*
engraving, 2
escallop, *26*, 60
escarbuncle, *24*, 45, 60
escutcheon, *9*, *14*, 45, 60
Estella (Spain), capital, 27
estoile, 16, *18*, 45, 60

Fakenham, 40
Faussett Collection, 1
Felbrigg, arms of, 16, 36, 53
Felthorpe, 5, 45
Feltwell, 36
fermaux, *13*, 45, 60
Ferrers de
 family, 8
 Lord -, Earl of Derby, arms of, 49, 53
fess, *11*, *13*, *15*, *18*, *20*, *22*, *24*, 45–6
Field Dalling, 49
Filby, 38
Fincham, 37, 38, 40, 41, 42, 44, 52
fish, 46
FitzGeffrey, arms of, 50, 53
FitzJohn
 arms of, 50, 53
 Robert, arms of, 8, 46, 53
FitzPiers, Earl of Essex, arms of, 50, 53
FitzWalter, arms of, 46, 53
Fleggburgh, 51
fleur-de-lis, *6*, 8–9, *14*, *19*–20, 23, *24*–5, 46–7, 60
Flore, arms of, 47, 53
flower, *12*, 47

foil, *8*, *13*, *21*, *25*, 47
Fordham, 36
Fordington (Dorset), tympanum, *27*
Foxley, 39, 40, 49
France, arms of, 18, 47, 53; *see also* England and France, arms of
Fransham, 34, 45, 47
Freethorpe, 34
fret, *6*, *7*, 28, 47, 60
fretty, *6*, *10*, *13*, *19*, 48, 60
Freville, Baldwin de, arms of, 44, 53
Fring, 39, 43
Fulmodeston, 44
function *see* use
fusil, *12*, *19*, 48, 60

Gayton, 34, 47
George, St, arms of, 43, 54
gilding, 2
Gimingham, 46
glossary, 59–62
Great Dunham, 36, 44
Great Hautbois, 46
Great Ryburgh, 46
Great Walsingham, 38
Gresham, 40
Grey, de, family, arms of, 34, 53
griffin, *8*, *12*, *21*, 23, *25*, 29, 49, 60
Griffiths, Nick, 1
Grimston, 26, 47
Grindale (Grymeles; Grymes), Robert de, arms of, 44, 53
Groby (Leics), 49
gryllus, 16, *17*, 49
Grymeles/Grymes *see* Grindale
Guist, 51
Guyenne, Duke of, arms of, 18, 35, 53
gyronny, *11*, 28, 48, 60

Hainalt, Philippa de, arms of, 39, 53
Hales, 35
Hales, arms of, 42, 53
Halley's comet, 7
Happisburgh, 43
Hargost, arms of, 49, 53
Harling, 47, 52
hart and in base, *12*, 34
Hatton (Hotton), arms of, 42, 53
Haveringland, 47
Heacham, 35
head, 16, *17*, *24*, 48
Helias, Count, 27–8
Hellesdon, 47
Hemsby, 42
Hengrave (Suffolk), 42
Hengrave, Edmund de, arms of, 42, 53
Henry I, 8
Henry III of Navarre, wife of, 45
Hethersett, 40, 46
Hevingham, 30, 46, 49
Holland, Earl of Kent, arms of, 39, 53
Holme Hale, 45
Holme-next-the-Sea, 35
Holt, 42
Honing, 42
Hopton on Sea, 46, 49
Horning, 34, 35, 43, 45, 49, 50
Horsford, 42
Horsham St Faith, 40, 41, 42, 45, 48, 51
Hotton *see* Hatton
Howe, 49
human, 48

Ingham, Oliver de, arms of, 44, 53
Ingoldisthorpe, 45, 52
inscriptions, 7, *8*, *9*, 35, 43
Isabella, Queen, 23
Isell (Cumbria), 34, 41

Jenkins, T.B., 1

Kelling, 43
Kempley (Glos), polychrome painting, 29
Kenninghall, 37, 41
Keswick, 23
Ketteringham, 39, 43, 47
Kettlestone, 48
key, 23, *26*
king's head, 16, *17*
Kinoulton (Notts), 46
Kirby Beler, 37
knot, *7*, 23, *26*, 48–9

label, *12*, 49, 60
Lancaster
 Henry, Duke of, arms of, 38, 53
 Thomas, Earl of, arms of, 38, 53
 see also Crouchback, Edmund
Langer (Notts), 51
Langham, 38
Le Mans (France), Limoges enamel, 29
leaf, 49
leaves, 24, 49
letter, 18, *20*, *24*, 49
lettering, 7
Leybourne, de, arms of, 39, 53
Limesy, Ralph de, arms of, 41, 53
Lindsay, Philip de, arms of, 8, 40–1, 53
lion, 8–9, 16, 23, 26, 29
 four lions, *14*, 39
 passant/passant guardant, *8*, *9*, *12*, *19*, *21*, 34–6
 rampant, *6*, *10–12*, *14–17*, *20–1*, *24*, 36–7
 serjant erect, 37
 six lions, *12*, 39
 three lions, *10–11*, *13–15*, *19–21*, *25*, 38–9
 two lions, *9*, *19*, 37–8
Little Barningham, 44, 46
Little Cressingham, 38
Little Dunham, 36, 38
Little Fransham, 34
Little Snoring, 48, 49
Little Walsingham, 43, 52
Loddon, 34, 38
Lode (Cambs), 7
lozenge, *5*, 28, 49, 60
lozengy, *14*, 49, 60
Ludham, 51

manufacture, 4
Mappa Mundi, 1
Marcy, Louis, 9
Margeson, S., 1
Marham, 40
Marshall, Gilbert, Earl of Pembroke, effigy, 9
Marsham, 49
Marston (Lincs), 40
Martham, 34, 48
mascules, *10*, 49, 60
Mattishall, 48
Mautby, 37
Mendham Priory (Suffolk), arms of, 46, 53
Mileham, 40
milites, 27
mitres, *17*, *21*, 49, 60
Modena (Italy), carving, 27
Mohaut, Robert de, arms of, 36, 53
Moigne, John le, arms of, 8, 51, 53
Monreale (Sicily), running vine decoration, 29
monster, *7*, *8*, 29, 49–50, 60; *see also* dragon; griffin; gryllus; unicorn; wyvern
Montagu, Simon and William de, arms of, 8, 48, 53
Montgomery, arms of, 47, 53
Moone, arms of, 43, 53
Morley, William and Robert de, arms of, 30, 37, 53
Morton-on-the-Hill, 36
mount, *6*, *24*, 50, 60
mounts
 described
 C12–early C13, *5–7*
 circular, 18, *20*
 lozengiform, 16, *18*
 from sets, 23, *25*
 shield-shaped, 8, *16*
 square/rectangular, 18, *19*
 trefoil, quatrefoil and elaborate quatrefoil, *22*, 23
 origins, 27–8
 use of, 4
Mowbray, Roger de, 28
Mulbarton, 51
mullet, *9*, 50, 60
Multon, Hubert de, arms of, 34, 41, 53
Mundham, 35, 48
Myltecombe (Myttecombe), arms of, 48, 53

Narford, 50
Navarre and Champagne, arms of, 45, 53
Neville, arms of, 36, 53
Normandy, arms of, 18, 37, 53
North Creake, 34, 44, 48
North Elmham, 26, 43
North Lopham, 39, 42
North Tuddenham, 47
North Walsham, 37, 46
Norwich
 Bishop of, arms of, 30, 45, 49, 53; *see also* Percy
 castle
 constable of, 46
 finds from, 4, 18
 keeper of, 42
 church of St Gregory, 16
 finds from, 37, 39, 40, 45
 castle, 4, 18
 Castle Mall, 43
 Greyfriars, 5, 41
nutmeg grater, 28

Odo, Bishop of Bayeux, 5
Ogand, arms of, 45, 53
Ormesby St Margaret, 43
owl, 18, *20*, 41
ownership, 30–1
Oxborough, 38, 44, 45, 48, 49

pall, *16*, 50, 61
paly, *10*, 16, 50, 61
peacock, *11*, *12*, 41, 61
pelican, *25*, 41, 61
pellet, 28
pendants
 described
 C12–early C13, *5–7*, 8, *9*, 28
 circular, 18, *20*
 lobed rectangular, *14*
 lozengiform, 16, *17*, 23
 non-armorial, 4, *5*
 octagonal and elaborate, 23, *24*
 shield-shaped, 8–9, *10–14*
 square/rectangular, 18, *19*
 trefoil, quatrefoil and elaborate quatrefoil, *21–2*, 23
 origins, 27–8
 use of, 4
 see also trial-piece
Pentney, 49
Percy
 Algernon, Bishop of Norwich, arms of, 37, 54
 Thomas, Bishop of Norwich, arms of, 37, 54
Peverel, Andrew and Thomas of, arms of, 48, 54
Pickering *see* Pykeryng
Plantagenet, Geoffrey, 29
Poitou, Alphonse, Count of, arms, 18, 47, 54
Postwick, 39, 42, 45, 47, 48, 49, 51
Poynings of Sussex, 23
Pykeryng, arms of, 37, 54

quarterly, *12*, *22*, 23, *24*, 50–1, 61
Quidenham, 5, 35, 36, 39, 45, 49, 51
Quincy
 Margaret de, 49
 Roger de, Earl of Winchester, arms of, 49, 54

raven, 41
Reedham, 49
Reepham, 35, 50, 51
Reggio Emilia (Italy), enamel, 9
Reviers, Earl of Devon, arms of, 34, 54
Reymes, John de, arms of, 42, 54
Richard I, 28, 30
Riddlesworth, 23
Ringstead, 47
Ripe (Sussex), 48
Roach-Smith, Charles, 1
Robert I, 8
Robert, Count of Mortain, 5
Rollesby, 39
Rosselyne, Sire William, arms of, 45, 54
Rothing, John de, arms of, 34, 54
Roudham, 26, 36, 41, 48, 49, 51
Roumare, William de, Earl of Lincoln, 28
roves, 9
Roydon, 41
Rubercy (France), 7
running vine decoration, 29

saddle fittings, *15*, 16, 23
Saham Toney, 38
St Amand, Aumaury de, arms of, 48, 54
St Davids, Bishop of, arms of, 45, 54
Salle, 43, 46
saltire, 7, *10*, 51, 62
Scales, arms of, 4
Scarning, 5
Scholdham (Schouldham; Schuldham), arms of, 40, 54
Scole, 48
Sculthorpe, 41
Sea Palling, 44
Shelton, 52
Shepey (Leics), 46
Sherbourne, manor of, 35
Shipdham, 39, 49, 50
Shotesham, 47, 50, 51
Shouldham, 35, 46, 52
silvering, 2
Somery, Henry de, arms of, 39, 54
South Creake, 5
South Lopham, 48
Southacre, 45
Southwold, arms of, 45, 54
Sparham, 50, 51
Spixworth, 39, 40, 47
Sporle with Palgrave
 elaborate set, 8, 35, 36, 50
 pendants, 26, 37, 40, 42, 43, 45
 stud, 36
 suspension-mount, 47
Sprowston, 42
Stafford knot, 23, *26*
Stanfield, 49
star, *6*, 7, *20*, 51
stirrup studs, 9, *15*
Stody, 40
strap-ends, 9, *14*, 16
Stratton Strawless, 40
studs
 described
 circular, 18, *20*
 lozengiform, 16, *18*
 shield-shaped, 8, 9, *15*, 16
 square/rectangular, 18, *19*
 trefoil, quatrefoil and elaborate quatrefoil, *22*, 23
 use of, 4
Suffield, 34, 44
Suffield, Walter de, Bishop of Norwich, 30
Sumeri, arms of, 41, 54
Surlingham, 34, 41
suspension-mounts, 5–7, *14*, 18, *19*, 28
Sutton, arms of, 16, 37, 54
Swaffham, 44
Swafield, 48
swan, 41

Swannington, sculpture, *28*

Tacolneston, 38
Talbot, Richard, arms of, 40, 54
Tatterford, 33
Tattersett, 36, 37, 42, 43, 45
Tharston, 50
Thetford, 36, 37, 38, 48, 50
Thorpe Market, 39
Thuxton, 44
Tibetot *see* Tiptoft
Tidenham, arms of, 49, 54
Tiptoft (Tibetot), Robert de, arms of, 8, 51, 54
Toucy, de, arms of, 50, 54
 Jean de, 50
 Otton de, 50
 Otton de II, 50
Toulouse, cross of, 18, *19*, *20*, 44, 59
tree, 9, *17*, *25*, 51–2
trial-piece, lead, *4*, 44
Trowse with Newton, 51
Trubleville, arms of, 18, 35, 54
trumpets, 52
Trumpington (Cambs), 52
Trumpington, Giles and Roger de, arms of, 52, 54
Tuttington, 35, 37, 41

Ufford, Robert de, arms of, 4, 43, 54
unicorn, *12*, 50
Upper Sheringham, 40
use, 4

vair, *13*, *17*, 52, 62
Valoins (Valoynes; Valomys), arms of, 36, 54
Vane (Vanly; Vaulx; Vaux), arms of, 45, 54
Varennes (France), 5
Vermandois, Counts of, 27
Verona (Italy), church of San Zeno, 27

Wake, Baldwin, arms of, 9, 39, 54
Walpole St Peter, 26, 34, 36
Walsingham, 43, 45; *see also* Great Walsingham; Little Walsingham
Walsoken, 42
Ward-Perkins, J.B., 1
Warenne, Earls of Surrey
 arms of, 5, *6*, 8, 27, 30, 41, 54
 William de, Earl of Surrey, 5–7
Warham, 42, 50
Waterville, Robert de, arms of, 42, 54
Weeting with Broomhill, 41, 44
Wellingham, 44
Wereham, 40, 45
West Acre, 37, 40, 42
West Caister, 46
West Dereham, 48
West Rudham, 37, 38, 41, 42
West Winch, 36
Weybourne, 41, 46
Weyland
 arms of, 8, 37, 54
 John de, 37
 Roger de, 37
 Thomas de, 37
wheel, 52
Whelnetham (Suffolk), 37
Whissonsett, 38, 41
Wickmere, 39, 51
William I, 5
William II, 5
Winchelsea, arms of, 39, 54
wings, *13*, 52
Wisby, Battle of, 4
Wiveton, 44, 51
Woodton, 50
Wormegay, 8, 43
Wramplingham, 36
Wreningham, 38
Wymondham, 26, 39
wyvern, 7, 8, *8*, *9*, 50